St. Jude Children's
Research Hospital ®
ALSAC · Danny Thomas, Founder
Finding cures. Saving children.

stjude.org

S

URE

Christmas, 2016

Susan
mike
Emily

to Virginia

IMAGES
of America
MILWAUKEE'S
EARLY ARCHITECTURE

Megan E. Daniels

ARCADIA
PUBLISHING

Published by Arcadia Publishing
Charleston, South Carolina

Printed in the United States of America

Library of Congress Control Number: 2010927341

For all general information contact Arcadia Publishing at:
Telephone 843-853-2070
Fax 843-853-0044
E-mail sales@arcadiapublishing.com
For customer service and orders:
Toll-Free 1-888-313-2665

Visit us on the Internet at www.arcadiapublishing.com

*This book is dedicated first to my grandfather Herbert Daniels
and second to Gipfel Union Brewery, demolished
during the writing of this book.*

CONTENTS

ACKNOWLEDGMENTS

The Milwaukee Preservation Commission has collected a wealth of research and photographs over the past 30 years documenting Milwaukee's historic architecture in an effort to protect designated historic buildings, advise their restoration, and ensure the overall preservation of Milwaukee's historic architecture. This collection of research and photographs has been an invaluable tool in the research conducted for this book. A special thanks to Carlen Hatala for welcoming me into her office and sharing a similar passion for Milwaukee's architecture. The Milwaukee Public Library likewise maintains the Historic Photo Collection documenting Milwaukee's history and architecture as early as the late 19th century. Photographs such as these are all that remain to testify to the original views and grandeur of Milwaukee's early architecture. The photographs in this books were provided courtesy of these two organizations as well as two third-party contributors. Unless otherwise noted, all photographs come from the author's personal collection. A final thank-you to my editor at Arcadia Publishing, Jeff Ruetsche, for seeing me through this project; to everyone at apartment number two for their continued support and inspiration; and to my family, friends, and colleagues for their continued interest and encouragement.

INTRODUCTION

The completion of the Erie Canal had great consequences for the soon-to-open Midwestern frontier. It promoted continuous westward travel from the Hudson River at Albany to Lake Erie at the city of Buffalo and continuing through the chain of Great Lakes, providing an alternate migration route to the Northwest Territory. Settlement began at the peak of water transport, when Milwaukee's harbor and rivers drew interest to the area. As the largest bay and deepest river on the western shore of Lake Michigan, Milwaukee was soon envisioned as a great port city to connect the Midwest with the East coast and possibly even European markets.

Just as Milwaukee's topography roused interest, so did it influenced the city's development. The Milwaukee and Menomonee Rivers divided the region into east, west, and south, each covered by massive bluffs and marshes; however, the city's potential as a major port was far more important than its swampland. While it is common for cities to expand radially from a historic center, Milwaukee grew from the centers of three villages. Commercial and residential development was heavily influenced by the three villages that would forge around the trading posts of the city's founding fathers, each settling on the highest and driest ground of their respective parcels. Having established a seasonal trading post in Milwaukee over a decade before permanent settlement began in 1833, Canadian fur trader Solomon Juneau purchased the land east of the Milwaukee River to Lake Michigan. Fur trading took a downward turn after Native Americans were forced out of their lands; consequently, Juneau looked to land speculation for income with the help of business partner Martin Morgan. Shortly after, surveyor Byron Kilbourn was sent by his employer to scout the Milwaukee area in 1834. The son of an Ohio speculator and a notorious businessman, Kilbourn saw Milwaukee's potential to serve the farmers in the surrounding hinterland as the only port city between Chicago and Green Bay. Kilbourn took up the west portion under the assumption that all westbound traffic from Juneau's settlement would be routed through his. Thus the rivalry was born, fueling a competition that would have great effects on the city's development and character. Lacking the resources and experience of Solomon Juneau and the business tactics of Byron Kilbourn, Milwaukee's third founding father lagged behind in establishing ownership of his settlement. Virginia native George Walker fought for legal ownership of his land for seven years after his initial arrival at the southern point of land near the confluence of the Milwaukee and Menomonee Rivers. Finally in 1842, Walker was afforded ownership of his land and was able to begin secure development. Four years later, the city of Milwaukee was born with the adoption of the city charter in 1846.

The flood gates opened in 1835 as Milwaukee was overcome with speculators and settlers alike. Predominantly a homogeny of New Yorkers and New Englanders making their way to the frontier in search of boom fortune no longer available along the much developed East Coast, these so-called "Yankees" brought with them the political, cultural, and religious institutions from the eastern seaboard. In the late 1840s, the Yankees were met with a flood of German emigration. Political unrest in the German states and the European Revolution of 1848 coincided with Wisconsin's

statehood and its popularity as the latest frontier, accounting for the large number of German immigrants. In addition, Germans—unlike some of their immigrant counterparts—had the resources to travel onto the frontier rather than settle amongst the eastern states in search of immediate employment. German immigrants infiltrated all areas of Milwaukee as they ranged in income and educational levels from laborers, skilled workers, merchants, entrepreneurs, and politicians. The religious make-up of Germans was likewise stratified between Lutheran, Catholic, and Jewish, many having left for religious purposes. So diversified within themselves, the Germans did not create a subculture but rather transposed their culture onto Milwaukee. An unsung hero of sorts, Milwaukee's Polish population would later develop to be the second largest immigrant population at the close of the 19th century. Likewise, leaving occupied Poland because of political unrest, Polish immigrants may well have found their way to Milwaukee as the majority were from the German occupied states and left Europe via the harbors of Hamburg and Bremen. Until World War I, Milwaukee welcomed a copious number of European immigrants, from British, Welsh, Irish, and Scandinavian early on to Serbian, Croatian, Balkan, Russian, Greek, and Italian nearer the turn of the century; however, none were as populous as the German and Polish. Of all the ethnic groups in Milwaukee, only the Germans and Poles left behind a wide range of architecture reflective of their ethnicity. This likely occurred because of their great numbers, as the Germans and Poles together comprised more than three quarters of the city's population by the turn of the 20th century.

As it were, tensions existed between ethnicities early on and Yankees, Germans, and the Irish segregated themselves accordingly. As a large concentration of Yankees migrated to the high ground of Juneau's settlement, Juneautown, the first German settlements were established on either side of the Milwaukee River between Juneau Avenue and Wells Street. The largest concentration existed near Third Street and Juneau Avenue surrounding Kilbourn's original settlement, Kilbourntown. The Irish established a strong community in the Third Ward near the wholesaling district where many were employed. Coincidentally, Walker's Point has always enjoyed diversity as home to British, German, Irish, and a small Scandanavian population. When the Poles arrived after the Civil War, they initially settled two of the yet undeveloped enclaves just south of Walker's Point along West Mitchell Street and just north of Yankee Hill along East Brady Street. As such, these initial settlements are indicative of the collection of architecture that would follow suit in the decades to come. Likewise, as prosperity and population continued to grow, the city continued to expand in all directions. Each neighborhood that exists today is a product of these self-sustaining communities, each developing unique characteristics and charm based on their response to their own heritage, local culture, and national architectural movements. The architecture produced by Milwaukee's residents was a response to events, a product of social movements, political affairs, and technological advancements—a beacon of the city's cultural history. As architecture narrates the story of the people it harbors and the city it inhabits, the remnants of Milwaukee's early architecture stands as a visual account of its history and formation.

One

PIONEER ARCHITECTURE

Milwaukee's earliest construction was heavily influenced by the region's topography of wide marshes, massive bluffs, and the Milwaukee and Menomonee Rivers dividing the region into east, west, and south. The earliest structures were simple shelters constructed on available dry land with close proximity to the harbor and the Milwaukee River, as water transport was the predominant mode of transportation and shipping. Having constructed his trading post on a portion of dry land near the mouth of the Milwaukee River at what is now Water Street at Wisconsin Avenue, Solomon Juneau purchased the land east of the Milwaukee River with the help of his business partner, Martin Morgan, in 1833. In 1834, Byron Kilbourn followed with his purchase of lands west of the river setting at Third Street and what is now Juneau Avenue. A benign competitor, George Walker arrived in 1834 lacking the tenacity of Kilbourn and the resources of Juneau, settling at the junction of the Milwaukee and Menomonee Rivers. In 1835, permanent property lines were established and streets platted according to a grid plan disregarding the natural topography. Fueled by Kilbourn and Juneau's rivalry, the streets were misaligned across the river and given different names; however, their competition produced an early establishment of amenities, making Milwaukee attractive to prospective settlers. Before the 1840s, speculators began dramatically altering the topography, leveling the bluffs and filling in marshes. Construction radiated outward from Juneau's trading post along Water Street, as it did from Kilbourn's settlement at Third Street. Substantial wood frame buildings were constructed by 1835, followed by the first brick residences in the 1840s. Frontier life demanded simple architecture built out of necessity for functional purposes with limited finances and use of the region's natural resources, such as wood and cream brick from local clay deposits. The buildings revealed their structure and construction methods, uninfluenced by wealth or social status, rarely exceeding one to three stories and being rectangular or square in plan. A lack of skilled architects and master builders accounted for the unadorned, unpretentious buildings that began as simplified renditions of styles transported from the East Coast later being influenced by the building traditions of European immigrants as well as acquiring size and detail as the pioneer age drew to a close with the death of Solomon Juneau in 1856.

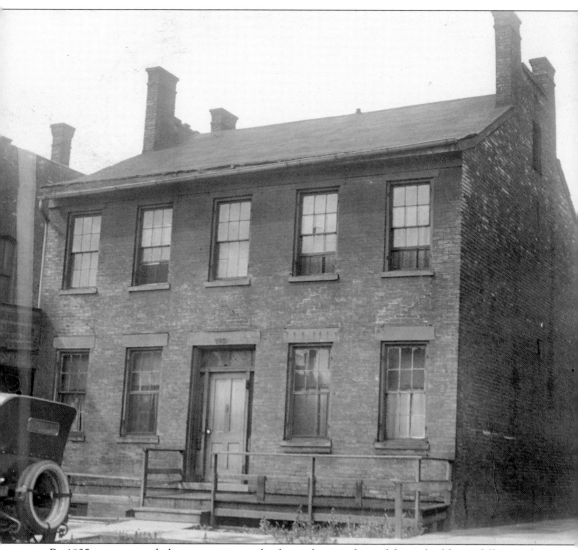

By 1835, temporary shelters gave way to the first substantial wood frame buildings, following by the first brick residences in the early 1840s. The Federal Style, originally popular on the east coast between 1785 and 1820, generically adapted itself to the Midwest streetscape as late as the 1850s. Two- to three-story, rectangular-plan buildings characterized by severe linear designs, slender proportions, symmetrically arranged windows, and twin gable–ended parapet walls were the hallmark of the brick buildings once very popular in the area that is currently Milwaukee's downtown. Unlike the majority of subsequent buildings in Milwaukee, Federal gables were set perpendicular to the street. (Courtesy of Historic Photo Collection/Milwaukee Public Library.)

Likewise transplanted from the east coast, Greek revival was intermingled with Federal architecture between 1840 and 1860. Reminiscent of Greek temples and monuments, Greek revival was elsewhere applied to buildings of great significance and monumentality, implementing columns, pediments, and other classical details. However, as the style migrated to the Midwest it was simplified, substituting pilasters for columns, eave returns for pediments, and simple cornices for the more elaborate classical details, as seen in the warehouse (above) constructed in 1839 along Water Street south of Chicago Street. In Milwaukee, the execution of this style carried a stark simplicity in its rectangular blocks of wood or cream brick rarely displaying ornamentation. Possibly one of the oldest churches in Milwaukee, the unadorned Greek Revival church (below) is indicative of the style. (Both, courtesy of Historic Photo Collection/Milwaukee Public Library.)

A simplified version of Greek revival in Milwaukee is seen at the home of New York native William Howard, constructed in 1854 for the canal and cargo ship worker along South Third Street in Walker's Point. The symmetrical window placement and squat proportions are characteristic of the style while the gable returns and pilasters at the entrance exhibit the simplification of the style as it migrated to the Midwest.

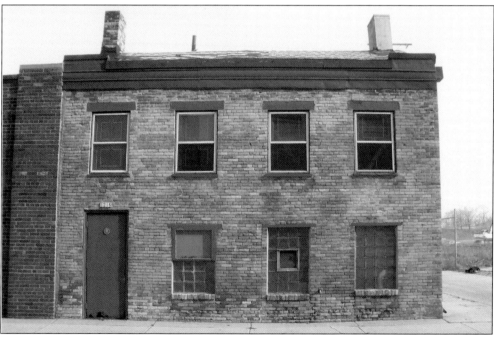

Between the 1840s and 1850s, double houses were common in Milwaukee's residential districts, often in the Federal style as it was conducive to multiple unit construction. A brick maker and mason, Alanson Sweet likely built the simple Walker's Point petite double house himself around 1845 when modesty and necessity dominated construction. In the 1930s, the northern half was razed, and the southern portion was later enveloped by surrounding industrial buildings.

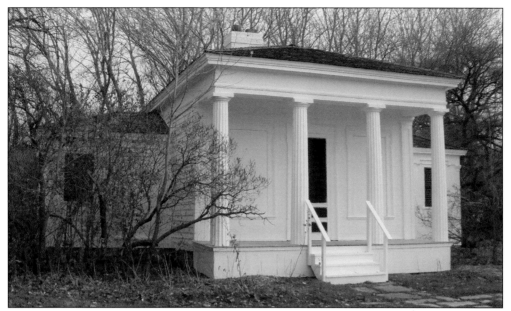

The distribution of building pattern books may have aided in designing Milwaukee's rare Greek Revival residence, the Benjamin Church house, displaying a full temple front with Doric columns. The home was constructed in 1843 by Church himself, a builder originally from New York, at North Fourth and Galena Streets near the heart of Kilbourntown. The residence was moved to its current location in Estabrook Park in the 1930s.

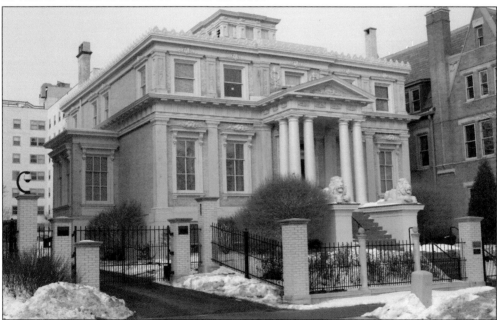

Similar movements based on Greek and Roman antiquity were thriving in Europe, though predominantly influenced by the elegant forms of Renaissance architecture. German native Edward Diedrichs constructed an impressive one-story Greek Revival residence often referred to as the "Lion House" with elegant Renaissance overtones in 1855. The second story was added in 1895, coinciding with a renewed interest in Classical designs at the turn of the century.

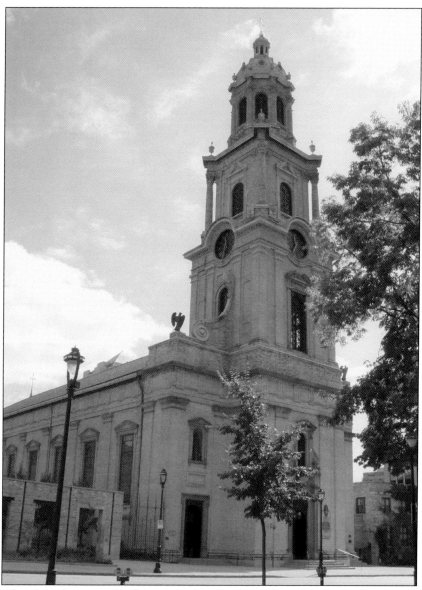

One of Milwaukee's first trained architects was German-born Victor Schulte. He began contributing German-influenced designs to Milwaukee's streetscape in the late 1840s with three of the first Roman Catholic churches exhibiting German Zopfstil. A stern response to the frivolous designs of late German Baroque and Rococo of the 18th century, the style appealed to the sober and simplistic designs popular in Milwaukee at the time with its streamlined, orderly symmetry, attention to proportions, and prudent detailing. The three German-designed churches utilize a similar rectilinear cornice as the Edward Diedrich home. The arrival of Bishop John Martin Henni, a German-speaking Swiss native, rooted the German Catholic immigrant church in Milwaukee, manifested by the construction of the city's first Roman Catholic Cathedral, St. John's, in 1847 on what was previously Courthouse Square. The nave walls, facade, and tower below the clock display austere Zopstil designs while the bulbous upper section was replaced by the current German Baroque tower in the 1890s. Schulte's Old St. Mary's and Holy Trinity executed similar Zopfstil renditions.

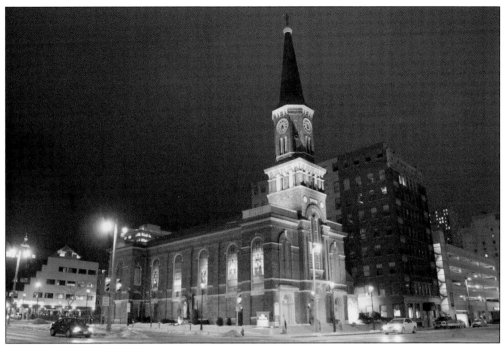

Old St. Mary's was the first parish to serve a predominantly German congregation. When originally constructed in 1846, St. Mary's was a two-story building with a school on the lower floor and a church auditorium on the second. In 1866, the first floor was eliminated and the auditorium floor lowered as a new rear addition, facade, and tower were added, reminiscent of the south and north walls' original fabric.

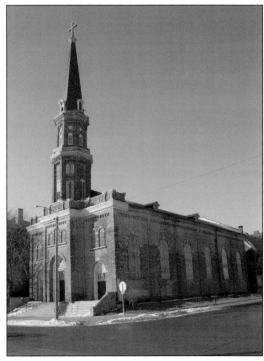

Holy Trinity Roman Catholic Church was designed by Schulte as the third Roman Catholic church in Milwaukee in 1849 serving German speaking immigrants, predominantly those from southern Germany and Austria having settled in Walker's Point. Holy Trinity was originally constructed without a steeple, but one was added in the 1860s according to the designs of Leonard Schmidtner. Presently the church has been renamed Our Lady of Guadalupe, serving Milwaukee's first Spanish-speaking congregation.

In the 1840s, a wave of German immigrants arrived at the recently opened Wisconsin frontier previously dominated by transplanted Yankees from New York and New England. In 1843, German-born David Gipfel began Gipfel Brewery between Fourth and Fifth Streets on Juneau Avenue, once considered "Brewery Row" with numerous small breweries stretching from Blatz on the east end and Pabst on the west. In 1853, a Federal-style commercial building was erected for Gipfel Union Brewery on the site of its previous brewery. With its unadorned walls and symmetrical windows, the building was considered one of the oldest Federal commercial buildings in Milwaukee and was the oldest standing brewery building until its recent demolition in 2009. In 1849, the brewery passed to Gipfel's eldest son, Charles Wilhem, at which time the brewery was renamed Union Brewery, producing lager beer until 1872, followed by the production of weiss beer into the 1890s when it was overcome by the brewing magnates of Pabst, Schlitz, and Blatz. (Courtesy of Historic Photo Collection/Milwaukee Public Library.)

Two

PRE–CIVIL WAR
VICTORIAN

By the late 1850s Milwaukee was no longer a mere settlement but had officially transformed into a small city; however, it was still operating within the realm of the original three villages. Distinct commercial and residential districts began to form as a consequence of the burgeoning city's growth. The central business district developed along Water Street near Solomon Juneau's trading post while Kilbourntown and Walker's Point began to develop commercial districts around the initial settlements of their own founders. Between 1850 and 1860, the city's population more than doubled, as did its business activity. In the preceding decades, Milwaukee had developed a number of newspapers, serviceable streets, hostelries, and a courthouse. Milwaukee had horse-drawn streetcars by 1850, gas street lights along major streets by 1852, and its first public school in 1857. Amongst the city's enterprises were flour mills, meat packers, tanners, and brewers earning a national reputation for beer production with over 24 breweries by 1856. Though still heavily dependent on water transport, the 1850s introduced railroads to Milwaukee, headed by Byron Kilbourn as president of the Milwaukee and Waukesha Railroad in 1849 and the LaCrosse and Milwaukee Railroad in 1852. The ensuing railroad epidemic established at least four railroads in Milwaukee in the 1850s. Although briefly paused by a financial panic in 1857, the city was quickly bolstered with the onset of the Civil War in 1861 and Milwaukee's entrance into the Industrial Revolution with Edward P. Allis' purchase of the Reliance Works company the same year. Milwaukee's industries flourished as a result of producing goods for the war effort, transforming Milwaukee's economy from one based on trade to one processing the region's agricultural resources into heavy industry and manufacturing. Moreover, the American Victorian era generally coincided with the Industrial revolution making new building materials available to more people. The simpler renditions of Greek Revival and Federal gave way to larger and more elaborately detailed Italian Renaissance Revival and Early Italianate commercial and residential buildings. Milwaukee's large collection of Victorian buildings is a consequence of the city's growth during this period.

As the site of Solomon Juneau's trading post, Water Street at Wisconsin Avenue has perpetually been the heart of Milwaukee's central business district and at the forefront of development. The intersection's importance was likewise a consequence of its proximity and accessibility to the harbor and the Milwaukee River. Ships were unable to dock near the shore, requiring dories to bring passengers and goods to the piers just south of Wisconsin Avenue; consequently, the first hostelries, taverns, and retail buildings were along Water Street and Broadway, then Main Street. Taverns and hostelries like Stimson's Hotel were the major social centers of early Milwaukee. Bailey Stimson was the owner and proprietor of the hotel, constructed at the northeast corner of Water Street and East St. Paul Avenue in 1853, catering to the English taste of Milwaukee's arriving settlers. Once boasting a fourth floor with an Italianate cornice, wrought iron balconies, and large windows along the first floor, the hotel as it is pictured managed to survive several fires as well as settling five feet into the marsh it was constructed upon until its demolition in 1980 after well over 100 years of perseverance. (Courtesy of Historic Photo Collection/Milwaukee Public Library.)

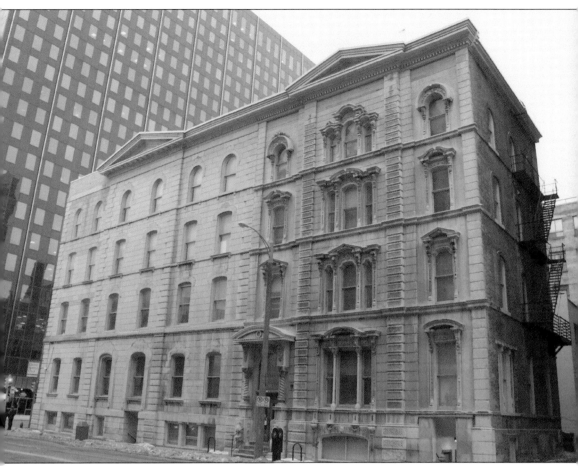

Water Street between Clybourn and Wisconsin Avenues was the first to be graded by Juneau and is consequently the oldest street in the city. Moreover, Clybourn Avenue, like Water Street, developed as a consequence of the first piers constructed in 1842 and 1843 at its east end until railroads began to dominate travel and transport over water transportation. By the late 1850s, Milwaukee had officially developed as a city, with its business community doubling between 1853 and 1857. The blocks of Water Street and Broadway between Wisconsin and Clybourn Avenues thus comprised the principal commercial center for Milwaukee's three villages. The early financial district was rooted along Michigan Street in 1846 with the construction of Alexander Mitchell's Marine Bank. A decade later, it was followed by the State Bank of Wisconsin (left) built across the street in 1856 at the northeast corner of Michigan and Water Streets. The Bank of Milwaukee (right) was constructed the following year abutting the State Bank's eastern facade. Both buildings exemplify the pre–Civil War Victorian architecture of the Italian Renaissance Revival style.

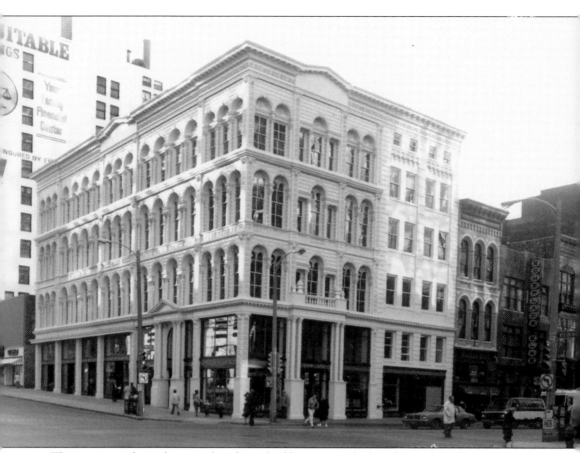

The ensuing industrial age produced new building materials that changed the face of Victorian architecture. During the 1840s and 1850s in New York, James Bogardus and Daniel Badger created catalogs of prefabricated iron facades with Italian Renaissance Revival designs that were cast on a previous site and applied to buildings elsewhere. However, it was not until 1860 that Baltimore native James Baynard Martin commissioned the construction of Milwaukee's Iron Block at Wisconsin Avenue and Water Street, with north and west facades of complete cast iron covering brick and timber framing. Often referred to as the Excelsior Block, the building housed a meeting hall for Excelsior Mason's, a bank, and professional offices. Cast iron facades were thought to be strong and fireproof and erected quickly with an elegant appearance; however, the facades were costly to maintain, requiring frequent painting to prevent rust. Moreover, the era of cast iron facades ended quickly with the great fires of Chicago and Boston, in which the heat weakened the facades to the point of collapse before flames even touched the building. (Courtesy of Milwaukee Historic Preservation Commission.)

Situated along the east side of Water Street between Michigan and Clybourn Streets, the Eliphalet Cramer building was designed by architect George Mygatt in 1854 to replace a building destroyed by fire the same year. The petite early Italianate building is one of the oldest known to survive intact in the central business district and a lasting remnant of the pre–Civil War commercial district.

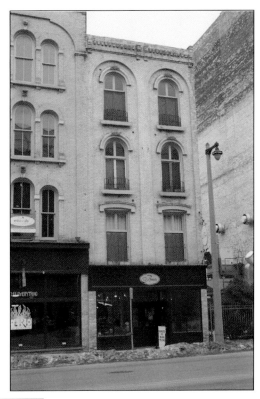

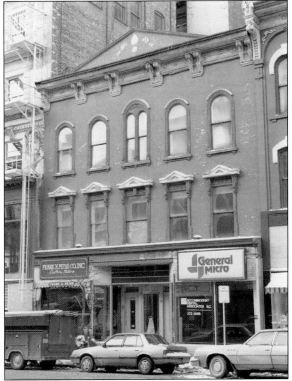

At the cusp of the Victorian era, the commercial district along Water Street and Broadway began its expansion east to Milwaukee Street north of Wisconsin Avenue, once a popular residential neighborhood for New York and New England Yankees. Vermont native George Bowman was said to have begun the transition with the construction of his general store in 1859 adjacent to his residence. The home was razed shortly thereafter in 1873. (Courtesy of Milwaukee Historic Preservation Commission.)

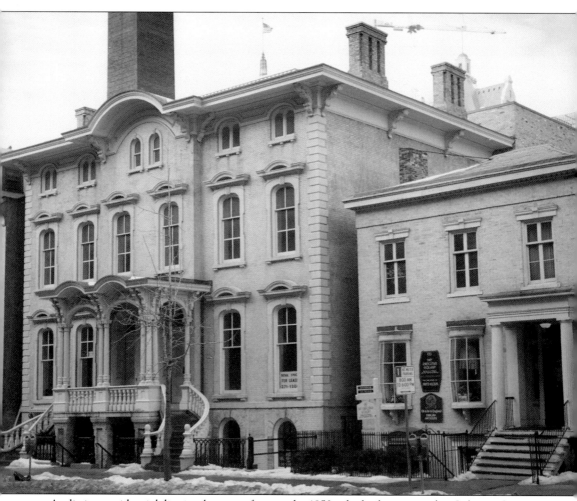

As distinct residential districts began to form in the 1850s, the highest ground in Solomon Juneau's settlement was developed predominantly by those originally from New England and New York. Accordingly, the neighborhood was referred to as Yankee Hill, originally bounded by Jefferson Avenue and Lake Michigan between Ogden and Wisconsin Avenues. Though it would eventually give way to commercial development, Jefferson Avenue did not enter the commercial district's expansion until years later. In 1858, billiard table maker William Weber erected twin houses (right) incorporating Greek Revival and Early Italianate influences with small Doric porticos. Matthew Keenan's residence (left), a cream brick Italianate double house, was erected only two years later in 1860 and exemplifies the architectural shift with its greater size and delicate Italianate treatment. Architect Edward Townsend Mix designed the magnificent mansion for the New York native early in his career designing a great number of Milwaukee's Victorian buildings. At the time the Keenan and Weber residences were constructed, the surrounding blocks were lined with Federal row houses and single family residences indicative of New England architecture. (Courtesy of Milwaukee Historic Preservation Commission.)

Third Street developed as the major commercial district for the German community that settled in the heart of Kilbourntown at North Third Street and Juneau Avenue, then Chestnut, and continued northward as the city expanded. The thoroughfare developed early, providing statewide connections to various plank roads north and south of Third Street. Throughout the Civil War era, the German commercial district consisted mostly of two-story frame buildings later replaced by large adjoined brick blocks as first generation German-American merchants continued to prosper. The two oldest blocks in the commercial district represent the restrained roots of Early Italianate architecture. The Adam Bauer Building (left) was erected around 1858 and is the oldest that currently remains on the thoroughfare. The Pritzlaff Hardware Building (right) was built next door in 1862 for German-born John Pritzlaff, designed by architect Leonard Schmidtner. The fourth story and mansard roof were added later in the early 1890s. Later the largest wholesale hardware firm in Milwaukee, the John Pritzlaff Hardware Company erected a complex at the southeast corner of Plankinton and St. Paul Avenues.

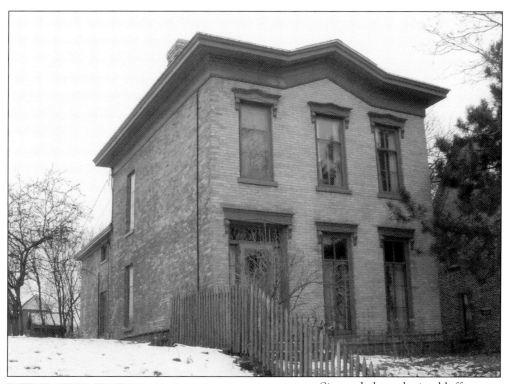

Situated along sloping bluffs overlooking the Milwaukee River just east of North Third Street, today's Dr. Martin Luther King Jr. Drive, the Victorian residential neighborhood of Brewer's Hill is one of two extant from the time of settlement. The irregular setbacks and spacing between houses are the hallmarks of an early neighborhood uninfluenced by zoning codes. Early Italianate was popularized in Milwaukee between 1850 and 1870, initially exhibiting influences from the preceding Federal and Greek revival styles in its flat surfaces and formal symmetry; those in Brewer's Hill date between 1855 and 1865. Most masonry residences (above) were generally cubic in plan with low hipped roofs, bracket eaves, and round or segmental arched windows. Wood frame homes (left) likewise display arched windows and often include a small oculus in addition to gable returns.

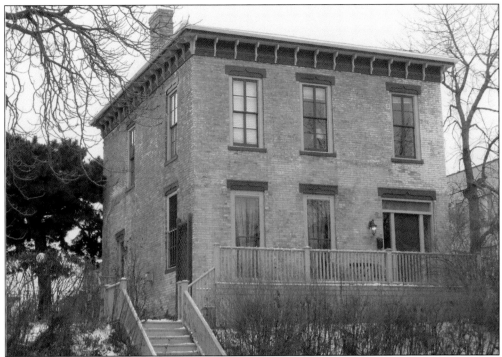

Brewer's Hill contains the best assemblage of transitional Greek Revival, Federal, and Early Italianate homes. Records indicating the original owner and construction date of this Brewer's Hill residence have been lost; however, the home dates to approximately 1858, exhibited by the presence of both Federal and Italianate designs. The home's flat wall surfaces and lintel framed windows speak to the Federal style while displaying Italianate bracketed eaves.

In Walker's Point, grocer Abel Decker erected this large Federal double house with Italianate detailing along South Third Street in 1857, incorporating an English basement, parapet walls, and bracket eaves. Double houses of this nature were once common fixtures in this neighborhood. Nearly lost to the wrecking ball in the 1980s, the Decker home has since been restored and is the best preserved of the style in Milwaukee.

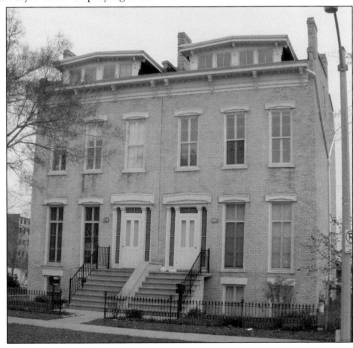

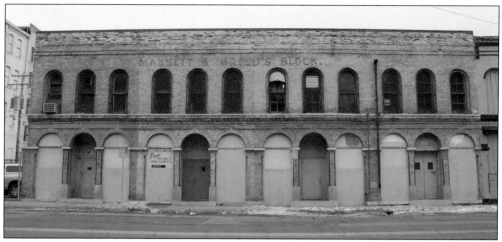

After two railroad depots were established along Florida Avenue in the 1850s, a small commercial district began developing amongst the filled marshes at South First and Second Streets just south of George Walker's original trading post at the junction of the Milwaukee and Menomonee Rivers. While the district exudes the later era of light manufacturing, two Early Italianate commercial blocks stand as remnants of the earliest commercial development. Hiram Mabbett and Charles Breed erected a two-story arcaded Italianate block (above) at South Second Street and Pittsburgh Avenue housing a variety of merchants, from leather and furniture retailers to a dry goods store and an apothecary. One block south, C. T. Stamm and Son's erected a large Italianate block (below) with lintel framed windows to house their hardware firm in 1865.

Three

POST–CIVIL WAR
VICTORIAN

The Civil War fueled Milwaukee's economy; as the south was ravaged by battle, the lower Mississippi was closed to commercial traffic routing business to the northern states. Consequently, Milwaukee's industries achieved great success producing goods for the war effort. Meat packers supplied food products for the Union army; tanneries turned hides for army boots, cartridge belts, and harnesses; and brewer's benefitted from the "war tax" applied to hard liquor, making beer the affordable beverage of choice. The population began to grow exponentially with increased job openings for immigrants and a displacement of wealth with larger portions of people in higher income brackets. Pioneering retailers and hostelries were soon accompanied by factory buildings as well as offices, commercial blocks, and headquarters for burgeoning partnerships. Banking and commodity trading developed along East Michigan; wholesale and commission offices along Water Street and Broadway; and professional and business offices at Broadway and Wisconsin Avenue. Commercial districts along North Third Street and in Walker's Point continued to develop as local retail and commercial centers. New industries created new building types that architects had yet to encounter. Architectural design ran rampant with exuberance, ornament, and considerable size as a means of identifying the occupants. The success found during the Civil War era created expansion and rebuilding in Milwaukee's business districts, enabling merchants to replace original wood frame buildings with larger masonry blocks, symbolizing their success, the need for more space, and a developing concern for fireproofing. Houses broke from simple rectangles to asymmetrical floor plans with elaborate exterior features. Unlike the all-encompassing one- and two-story boxes of the pioneer age, this period was an explosion of creativity in intricate forms and ornate details embodying the wealth of owners and the functionality and purpose of the structure. The architecture of the Victorian era showed the transition of Milwaukee from a small city to an urban manufacturing center influenced by the presence of new building types, new materials, and styles with more height and whimsical personal expression.

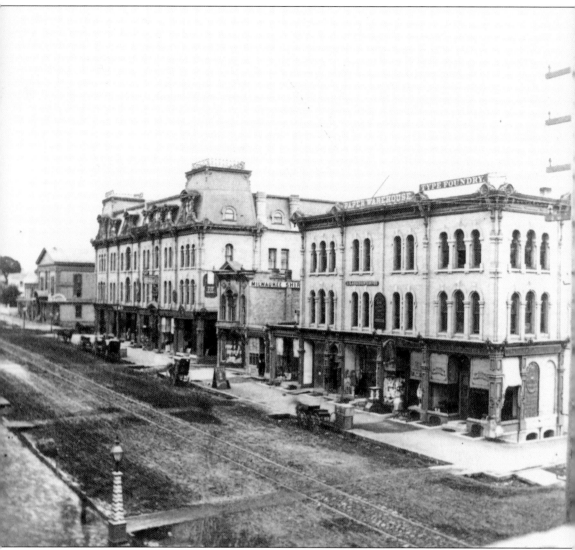

The heart of the central business district likewise sat at the forefront of change in the post–Civil War era. Previously Wisconsin Avenue east of Broadway had been primarily residential; however, commercial expansion east along the thoroughfare was spurred by a series of fires between 1860 and 1865 that leveled the existing wood frame buildings along the south side of Wisconsin Avenue between Water and Milwaukee Streets. In 1867, New York native Josiah Noonan erected an Italianate block (right) at the southeast corner of Wisconsin Avenue and Broadway where he housed his paper business and type foundry. Neighboring business man Alanson Follansbee likewise decided he would rebuild at the southwest corner of Wisconsin Avenue and Milwaukee Street (far left) with a block "nearly uniform" to the Noonan Block. Consequently, reciprocal commercial development soon commenced along the cross streets of Broadway and Milwaukee. Construction ensued in the central business district during the second half of the 1860s consisting mostly of small scale two- or three-story office buildings, wholesale blocks, and commission houses exhibiting the latter end of the Early Italianate Style. (Courtesy of the Historic Photo Collection/ Milwaukee Public Library.)

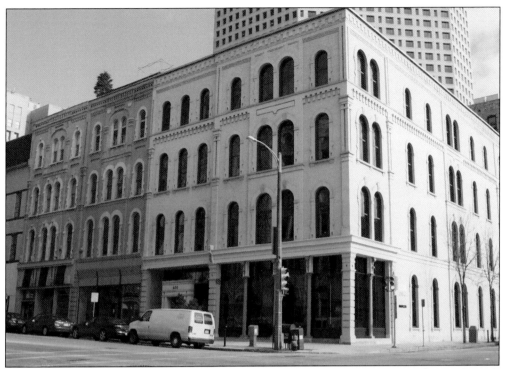

The Lawrence Block, a repercussion of the Noonan Building, was constructed in 1868 with seven ground level store fronts and three upper floors intended for office and manufacturing use. Though occupied by various tenants, the majority of its occupants were garment manufacturers and milliners. The fourth floor and original mansard roof underwent a series of alterations dating to the late 19th century.

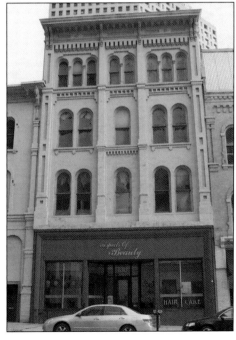

Likewise a repercussion of the Noonan Block, the four-story cream brick building was constructed in 1872, presumably for Guido Pfister, exemplifying the Italianate style with a deep bracketed pressed-metal cornice, heavy piers, and round arched windows. Similar buildings once extended along Broadway south of Michigan Street but have since been razed and replaced with parking lots and the 794 freeway.

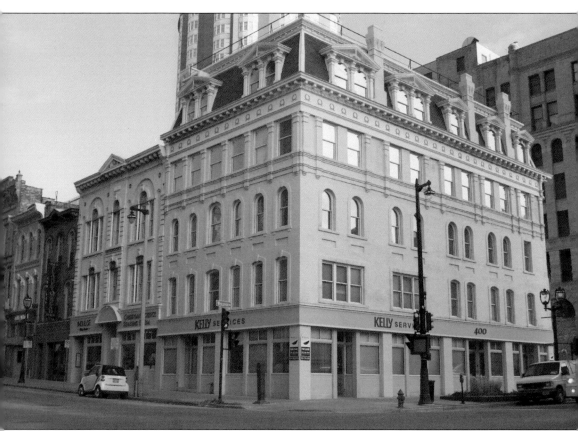

The 700 block of North Milwaukee Street, between Wisconsin Avenue and Mason Street, is indicative of the central business district just after the Civil War with the best assemblage of small scale Italianate commercial buildings. Beginning at the northeast corner of Milwaukee and Wisconsin, the street tells the tale of Victorian architectural progression as the east side of the street contains adjacent blocks built chronologically from 1866 to 1877. James Curry and A. J. W. Pierce commissioned construction of the two identical and connected Italianate blocks at the northeast corner of the intersection in 1866. The two were then adjoined to the Small building erected the same year directly north. Also constructed in 1866, the Brown Building stands next in succession to the Small Building. The four blocks maintain a similar Early Italianate appearance that is slightly more elaborate than the previously discussed Bowman Block across the street.

Both constructed in 1874 on opposite sides of North Milwaukee Street's 700 block, Brown and Bowman's second masonry blocks represent the development of Victorian Italianate with pronounced window framing and detailed brackets. Each building's round arched windows are pierced with carved keystones particular to Italianate architecture of the mid-1870s. As the Victorian era developed, buildings were continually designed with even more eye-catching facades as a means to draw attention to the occupants. Presumably, Bowman's residence, which stood adjacent to his 1859 building, was razed in 1873 for the construction of his second commercial block (right) designed by Edward Townsend Mix. Across the street, Dr. D. J. Brown erected his second building (below) as an income property adjacent to the block previously constructed to house his offices.

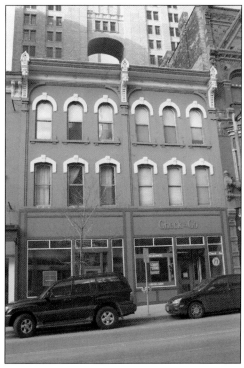

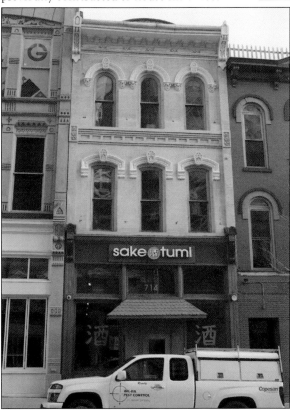

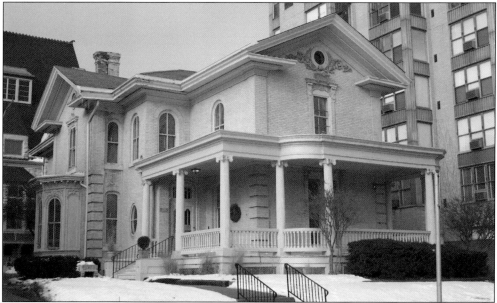

Because of its distance from Juneautown's commercial district, Burns Commons was not significantly populated until after the Civil War when commercial development pushed residential construction northeast into Yankee Hill. As was customary, speculator James H. Rogers donated a parcel of his land purchase for public use, initially called First Ward Park in 1847, now Burns Commons. An increasingly attractive location near Lake Michigan, Burns Commons experienced peak residential development during the 1870s. Located on Waverly Place, the Italianate home constructed for grain executive James S. Peck (above) in 1870 was once next door to the Edward Townsend Mix Residence, now razed. Across the park on Prospect Avenue (below), a lavish Italianate residence was constructed in 1874 for William Augustus Prentiss, who succeeded his Massachusetts political career with numerous political offices in Milwaukee's local government following his arrival in 1836.

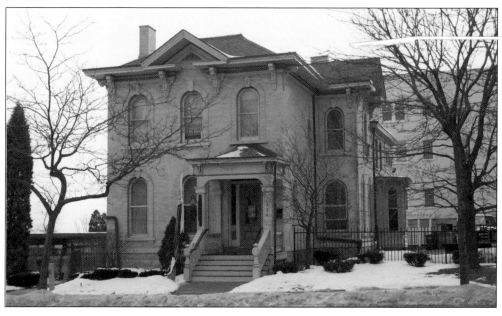

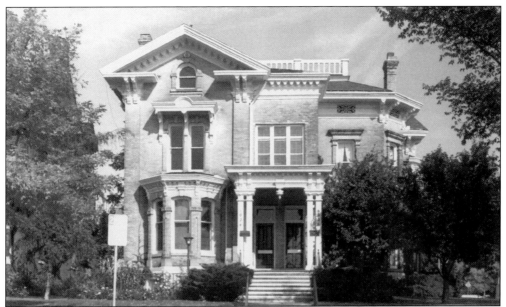

Inspired by 16th-century palace designs of the Italian Renaissance and country homes of rural Tuscany, Italianate residences were popularized by businessmen and professionals in the 1870s. Late Italianate residences were more flamboyant with towers, irregular massing, asymmetrical plans, cupolas, and detailed ornament such as the Henry Button residence (above) constructed in 1875 during Yankee Hill's peak development. Button's residence, designed by Edward Townsend Mix, once displayed a central tower, the upper stage now removed. Button's home, once the best of the Italianate homes in the Yankee Hill area, is now the only surviving Italianate mansion in Milwaukee. John Dietrich Inbusch was one of few German merchants to live and operate a successful wholesale grocery store in a neighborhood of predominantly British ancestry. Inbusch commissioned German architect Leonard Schmidter in 1874 to design his articulate Italianate residence (below) along North Cass Street. (Above, courtesy of Milwaukee Historic Preservation Commission.)

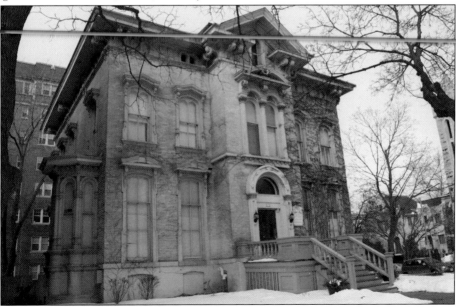

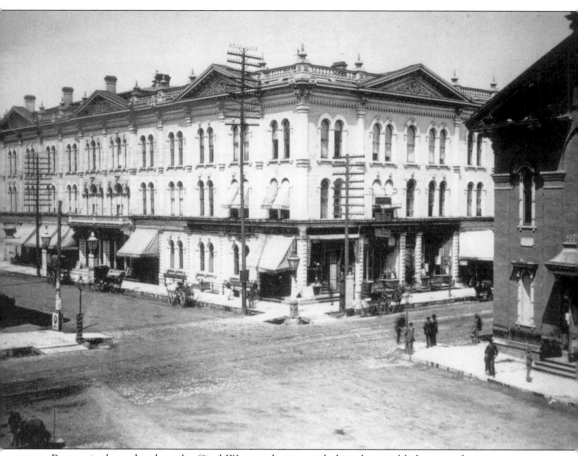

Prosperity brought about by Civil War production aided in the establishment of civic structures and other buildings outside the realm of necessity. In 1871, German-born businessman and theater enthusiast Jacob Nunnemacher was able to fulfill his aspirations of providing Milwaukee with its first opera house. Aside from the Germans that immigrated for religious reasons in Milwaukee's pioneer age, a group of rational thinking revolutionaries, the forty-eighters, fled the tumultuous German state for political reasons. The revolutionaries were responsible for the cultural wake that would earn Milwaukee the name "Duetsch-Athens," flooding the city with educational, musical, and social institutions that pursued and preserved German arts and culture. Shortly after their arrival, the forty-eighters established a German-speaking theater in 1851, the Liebhaberverein. Thus, the Nunnemacher Grand Opera House was constructed at the northwest corner of Wells and Water Streets in the center of Milwaukee's civic activity. On the far right, part of the old city hall is visible across Water Street. Previously a hall for the pioneer farmer's market, the building was converted to city hall in 1860. (Courtesy of archives department, University of Wisconsin-Milwaukee Libraries.)

Renovated to the appearance shown here in 1872, the Axtell Hotel (right) had been a direct result of Union Depot's location on South Second Street as one of many businesses to benefit from commuter traffic. Previously located two buildings east of the J. L. Burnham Building (below), Axtell House was forced to close after the railroads relocated downtown. Constructed in 1871, J. L. Burnham's building stands along East Seeboth Street as one of three surviving Italianate arcaded store fronts. John Burnham and his brother George were pioneer brick manufacturers supplying most of the brick for Milwaukee's early construction. Brick manufacturing boomed during the 1850s as product demands increased from cities like Chicago and St. Louis, earning Milwaukee the name "Cream City" by 1876 for its cream colored brick made from clay found along the shores of Lake Michigan and the Menomonee Valley. (Right, courtesy of Historic Photo Collection/ Milwaukee Public Library.)

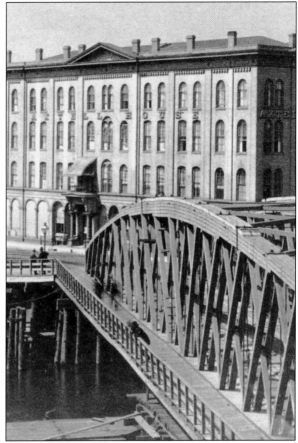

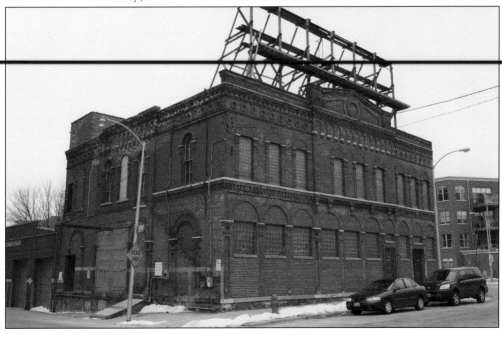

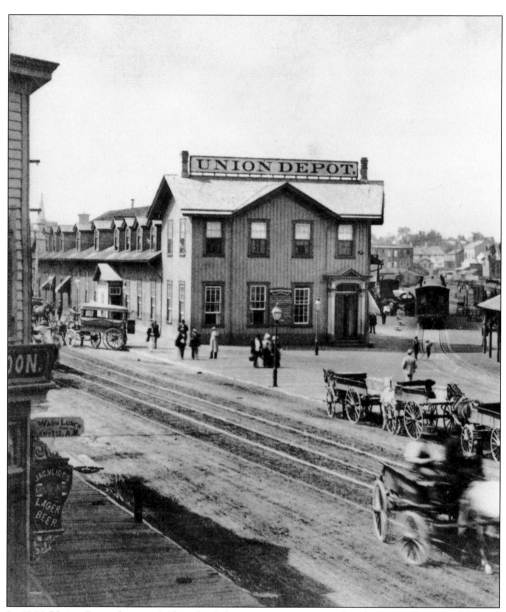

In 1866, Union Depot became Milwaukee's first major passenger railroad station when the Chicago and Northwestern Railway joined a southbound track to the Milwaukee Road terminus, which had yet to complete a line to Chicago. Located at South Second Street north of Seeboth Street, the terminus' locale bolstered Walker's Point commercial district along South First and Second Streets. In the decade preceding the Civil War, railroads had begun to play a crucial role in Walker's Point development, which may not have developed as it did without them. Seemingly, Walker's Point was a perfect location for settlement at the confluence of the Menomonee and Milwaukee Rivers near the mouth of the harbor. However, Byron Kilbourn had previously built a bridge between Walker's Point and Kilbourntown in 1838 connecting South Second Street and Plankinton Avenue, stunting Walker's Point's development in his efforts to ensure new arrivals would be readily escorted into his settlement north of the bridge. (Courtesy of Historic Photo Collection/Milwaukee Public Library.)

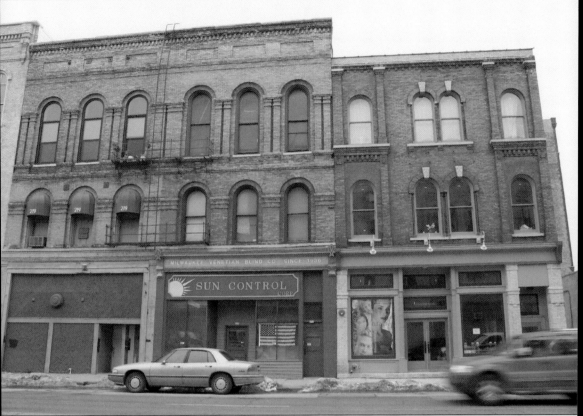

After Union Depot's establishment along the 100 block of South Second Street, the thoroughfare became the main commercial district until the 1880s. South Second Street expanded in order to accommodate increased traffic brought about by the passenger rail and the addition of a street car line. Merchants likewise accommodated the residential district located nearby at South Third and Fourth Streets. Merchants erected Italianate masonry blocks to house businesses such as the block erected along the 200 block of South Second Street for Joseph Maschauer and William Frankfurth's hardware and tin shop (left). Frankfurth had previously worked as a clerk in John Pritzlaff's north side hardware store. In addition, the prosperity of the district enabled merchants to construct new masonry buildings to replace existing wood frame establishments as grocer John C. Black erected the Italianate brick building (right) just north of Maschauer and Frankfurth.

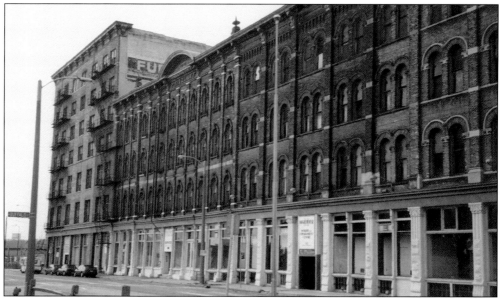

Located at the intersection of Plankinton and St. Paul Avenues near railroad and river access, the earliest buildings of the Pritzlaff Hardware complex were constructed in 1874. The complex remains with a high degree of preservation and stands as a completely intact group of buildings produced for one company. Complexes such as these are symbols of Milwaukee's industrial history and continue to stand along the Milwaukee River as enigmatic beacons of industries that once flourished. Factory buildings were a perplexing form of architecture during the industrial era without significant historical precedence and played a role in breaking buildings from the two story wooden boxes utilized in flour mills and grain elevators. Industrial era factory complexes were architect-designed structures of admirable artistry often adopting Italianate designs similar to those of early commercial blocks, as they were simple, sophisticated, and allowed for expansion in all directions. (Above, courtesy of Milwaukee Historic Preservation Commission.)

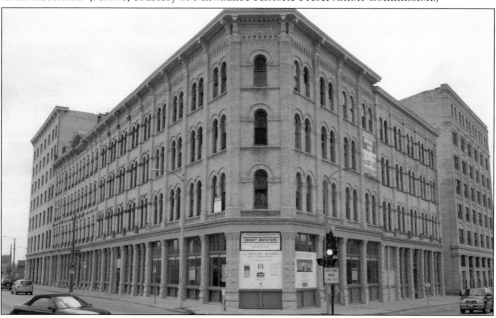

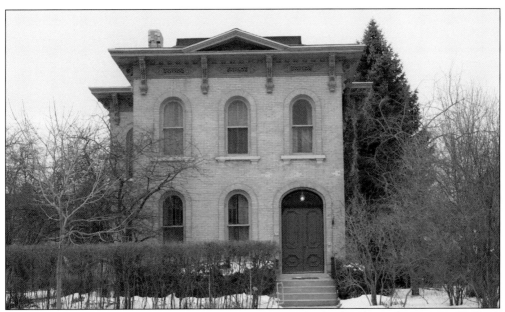

The residential district continued to grow south along South Third and Fourth Streets in Walker's Point with rather prestigious residences on either side of National Avenue. Walker's Point has always enjoyed a bit of diversity in its initial Yankee, German, and Scandinavian settlers followed by Welsh, Irish, Serbian, Croatian, and Balkan immigrants. However, South Third Street exhibits a testament to the region's German-American population with the homes of civil engineer Heliodore Hilbert, liquor wholesaler and rectifier Emil Schneider, and lumber merchant Emil Durr. Durr's partner, John Rugee, was a prominent master builder in Walker's Point constructing many buildings, including Durr's Victorian Gothic–inspired home in 1875 (below). In 1870, Emil Schneider's Italianate residence had been constructed north of Durr's with an intricate mansard porch, now removed.

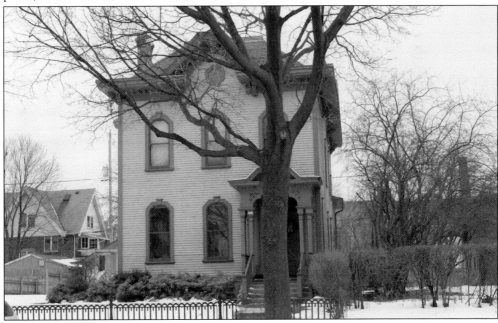

Like Walker's Point, Brewer's Hill enjoys an eclectic assemblage of worker's cottages, builder designed homes and prestigious residences. The Italianate building set along the sidewalk is characteristic of Milwaukee's earliest neighborhoods. Most likely constructed prior to its neighbors considering its simplified composition and wide-angled gable, the proprietor of the lower retail flat likely lived upstairs. The residences set back show the variation of modest Italianate residences in Brewer's Hill.

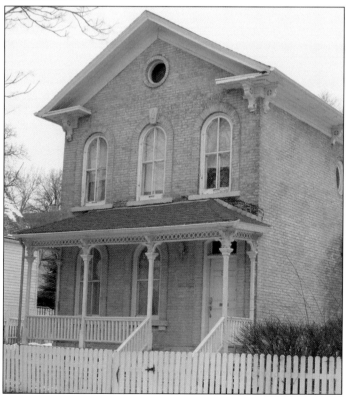

Sitting just before the bluff along East Vine Street in Brewer's Hill is a fine Italianate 1870s residence constructed by German-born mason Gottlob Schlenstedt. The home is a perfectly crafted modest Italianate home with pediment gable and oculus, arched windows, and mansard roofed porch with bracketed supports. Schlenstedt experienced a successful career in Milwaukee, occasionally contributing to the masonry of the Pabst, Schlitz, and Miller Brewery buildings.

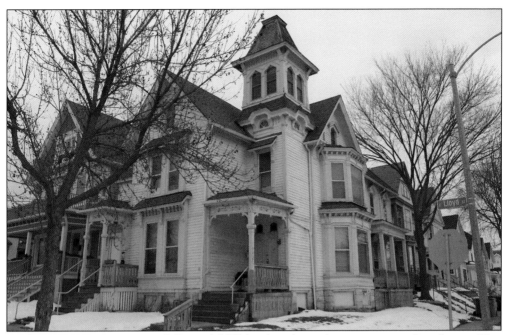

As the Victorian era continued, Brewer's Hill developed an eclectic variation of residences. This residence was originally constructed at the northwest corner of Holton Street and Garfield Avenue but was later moved to Hubbard and Lloyd Streets in 1892. It stands as an unusual example of a wood frame Italianate Villa, possibly alluding to the influences of Victorian Gothic in its mansard tower and peaked upper windows.

A testament to the nature of Victorian architecture, the Suess residence stands along North Palmer Street in Brewer's Hill. The rare and exuberant example of Victorian Gothic was designed by German-born architect Charles Gombert in 1881. Daniel Suess became the home's first resident and second owner in 1883, as the original owner went bankrupt prior to the home's completion.

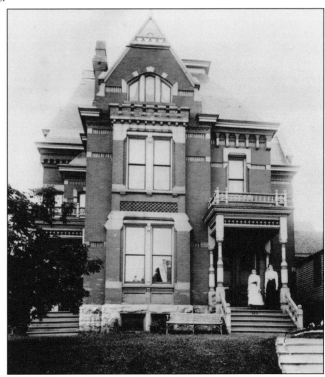

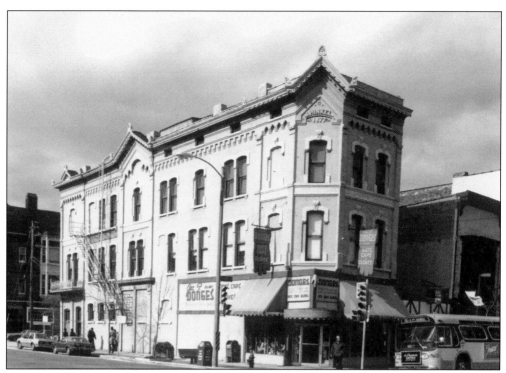

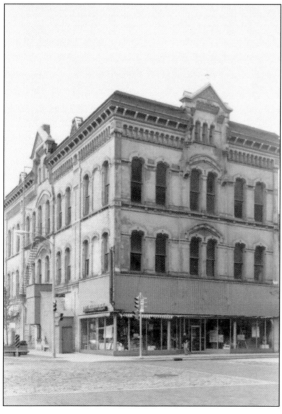

North Third Street continued to develop, further bolstered during the late 19th century when North Third Street and Wisconsin Avenue became main streetcar routes. German-born John Hinkel began his career in Milwaukee at the Philip Best Brewing Company in 1857 but resigned to establish his own saloon in 1877 at the corner of Third and States Streets (above). German natives John and Charlotte Lipps moved to Milwaukee in 1858, establishing a millinery business at Third Street and Highland Avenue. After two decades of success, the couple replaced their wood frame building with a Victorian Gothic commercial block (left) in 1878 designed by Charles Gombert in which the ground floor was leased to a succession of department stores. The district prospered until it was stunted by anti-German sentiments, the introduction of automobiles, and relocation to the suburbs. (Both, courtesy of Milwaukee Historic Preservation Commission.)

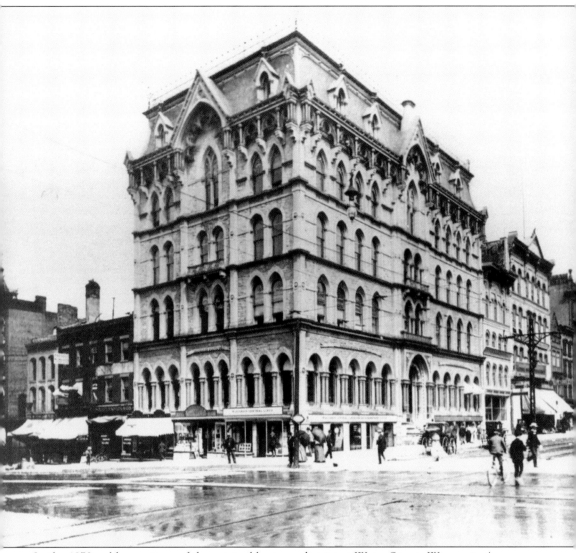

In the 1870s, older portions of the original business district at Water Street, Wisconsin Avenue, and Broadway were rebuilt to accommodate the need for more professional offices as banks, insurance companies, commission trades, and wholesaling businesses constructed new, larger buildings to accommodate their expanding business. Aside from years of success, Northwestern Mutual Life Insurance Company has boasted the grandest homes of the city's most prominent architectural styles. When the company elected to construct a new building in 1870, a Victorian Gothic office building was designed by architect Edward Townsend Mix and constructed at the northwest corner of Broadway and Wisconsin Avenue, perhaps the most impressive of its style. Victorian Gothic commercial buildings were once a common site along the streets of Milwaukee's downtown; however, most were razed during the 1950s and 1960s when the opulence of Victorian architecture was considered haughty and obnoxious. (Courtesy of Historic Photo Collection/ Milwaukee Public Library.)

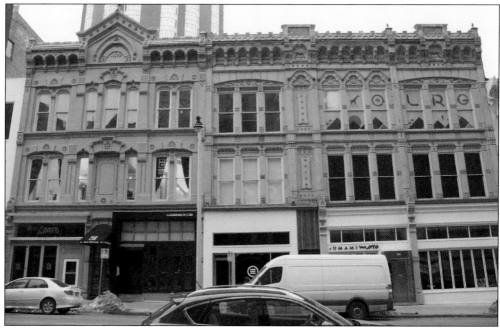

Victorian Gothic commercial buildings peaked in popularity in the late 1870s but continued to influence residential architecture into the early 1880s. In 1877, Edward Townsend Mix designed the two Victorian Gothic commercial buildings on North Milwaukee Street north of the Brown Buildings. The Steven's (above, left) and Arcade (above, right) blocks abandoned the traditional cream brick facade for more elaborate carved stone facing incised with intricate geometric and foliated detailing and were finished with elaborate corbelled cornices displaying a series of articulated arches. Possibly one of the largest wholesale shippers of coffee and spices west of the Alleghenies, the Jewett and Sherman Company erected a cream brick Victorian Gothic building (below) in the wholesale district along Broadway at St. Paul Avenue.

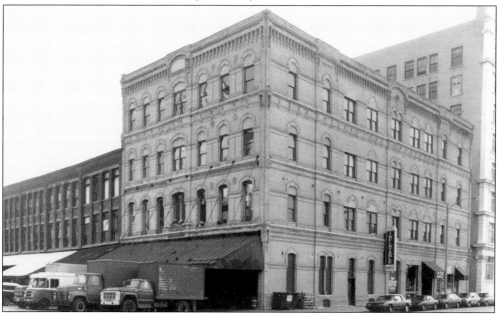

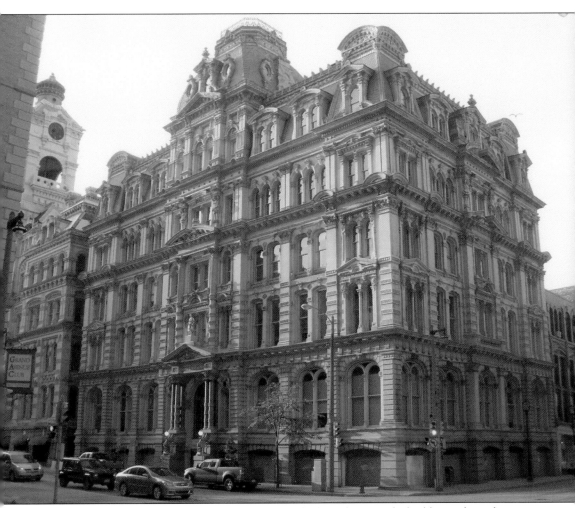

The French Second Empire style was popularized suddenly in the 1870s for buildings of significance and grandeur and vanished as quickly as it had appeared in the late 1870s. Wealthy industrialist and Scotsman Alexander Mitchell was no doubt the greatest proponent of the style in Milwaukee. The city's finest example of the style can be seen in the building erected by Mitchell on the site of his previous Marine Bank Building in order to house his three enterprises under one roof. The Mitchell Building, constructed in 1878 at the southeast corner of Water Street and Michigan Avenue, housed the Wisconsin Marine and Fire Insurance Company, Northwestern National Insurance Company, and the Milwaukee and St. Paul Railroad headquarters. Designed by architect Edward Townsend Mix, the Mitchell building displays all elements of the very elaborate and decorative style borrowing elements from French Baroque architecture with its sculptural facade, mansard dormer, and overlay of lavish Baroque detail. The Chamber of Commerce building constructed next door exhibits a subtle departure from the style just one year later.

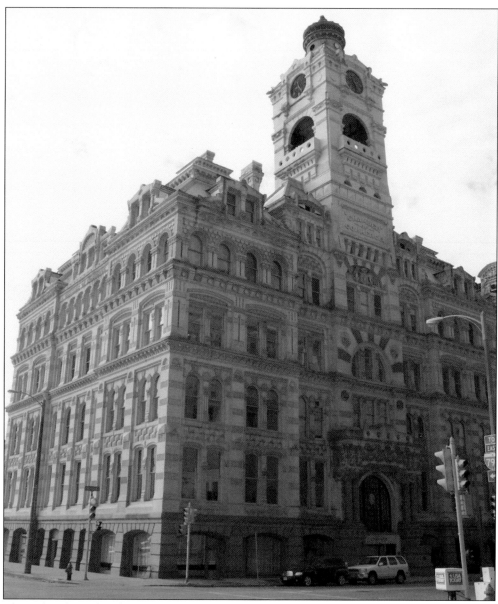

The Milwaukee Chamber of Commerce was commissioned by Alexander Mitchell in 1879 and likewise designed by Edward Townsend Mix. Always a businessman, Mitchell offered to replace the existing chamber of commerce adjacent to the Mitchell Building and lease the current one to them long term. Perhaps the building's greatest marvel was the three-story Grain Exchange room in which the trading pit was said to have originated, and the price of wheat was valued for national trade when Milwaukee was a leading producer of wheat in the country. The building was eventually renamed the Mackie Building after Mitchell's nephew, Mitchell Mackie. At the onset of the Great Depression, the chamber of commerce vacated the building when the market crashed; subsequently, the great exchange room was filled with the construction of small offices until its restoration began 40 years later in 1979.

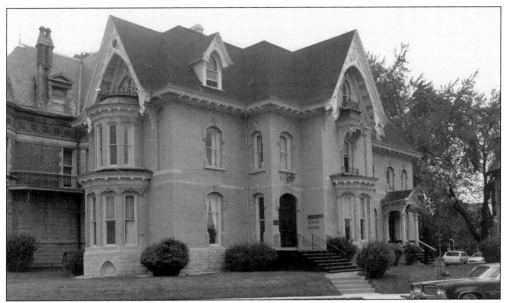

The Victorian Gothic cream brick residence was constructed alongside the Italianate residences in Burns Commons in 1874 according to the designs of neighboring architect Edward Townsend Mix. Constructed for prominent Milwaukee resident Jason Downer, the Vermont native established his own law practice in Milwaukee in the 1840s, continuing on to be Justice of the Wisconsin Supreme Court and a circuit judge in the 1860s. (Courtesy of Milwaukee Historic Preservation Commission.)

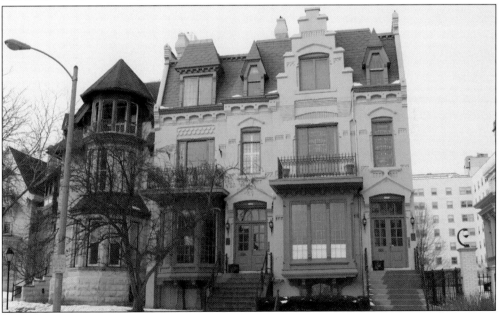

Constructed around the corner from the Downer residence is the unusual Victorian Gothic double house constructed in 1879 as an income property for Francis Hinton, a traveling salesman for the Milwaukee Iron Company. An unlikely character in First Ward Park neighborhood, the double house features English stairs, stepped gables, and a mansard-like roof between gable-ended walls that seemingly should be abutted with another building of this kind.

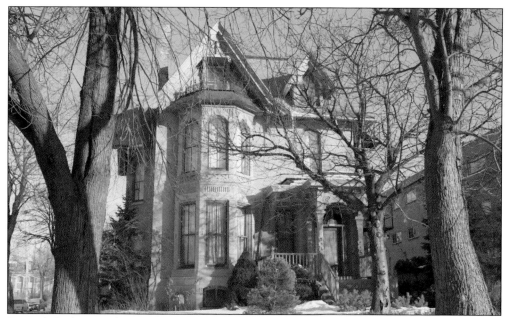

Several Gothic residences were constructed along the avenues of the west side prior to the neighborhood's heyday of mansion construction. Designed by builder-turned-architect James Douglas, the Victorian Gothic residence was constructed in an upper class neighborhood of the time along Wells Street for the widowed Chastina B. Walker and her son, Henry, in 1879. James Douglas earned a prolific reputation designing Victorian Gothic residences in Milwaukee.

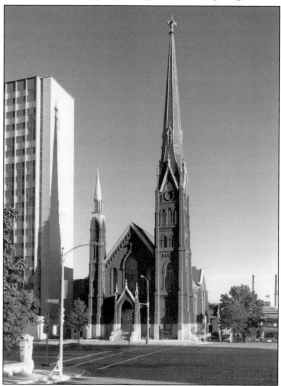

A testament to the success of its wealthy congregates, the Victorian Gothic church designed by Henry C. Koch and Julius Hess was constructed of cream brick in 1870 and boasted several influential members. The Calvary Presbyterian congregation had formed the previous year as west side members of First Presbyterian and North Presbyterian left to form a congregation closer to home. (Courtesy of Milwaukee Historic Preservation Commission.)

Four

ROMANESQUE
AND QUEEN ANNE

Around 1880, steel and iron manufacturing rose as Milwaukee's dominant industry in addition to meat packing, tanning, brewing, and flour milling, which continued through the turn of the century. During this period, manufacturers of all sorts began to buy out smaller counterparts, consolidating the number of businesses while increasing production. As a consequence of increased production, factories such as breweries, tanneries, and metal works continued expanding their complexes along the Milwaukee and Menomonee Rivers. Despite considerable prosperity, the turn of the 19th century was also a period in which the city experienced considerable unrest. Concern arose over Milwaukee's diminishing natural resources used in production, deforestation causing severe floods, air pollution from burning coal, and water pollution from the manufacturers lining the river banks. The late 19th century was overcome with labor unrest, strikes, and union movements as the factory system created a gap between the rich and the poor, putting distance between the industrial laborer and the industrialist. Skilled laborers were being replaced by unskilled in an era of poor wages for long work days and poor, often hazardous, working conditions. Likewise wrought with political unrest and corrupt government, this period ultimately led to the ascendance of the Socialist party. At this point, architecture takes a sober turn. By 1877, Milwaukee's pioneer landmarks had begun to disappear, and the 1876 Philadelphia Centennial Exposition had created a taste for the influences of late medieval English rural architecture revived in the Queen Anne style and the work of English architect Richard Norman Shaw, as well as the work of Boston architect Henry Hobson Richardson coined with his own style, Richardsonian Romanesque. While the two styles existed simultaneously, the more sober Richardsonian Romanesque seemed to be preferred for commercial architecture while the Queen Anne was most often executed for residential buildings. The two diverging styles peaked at the second half of the city's major boom period as the Victorian era drew to a close.

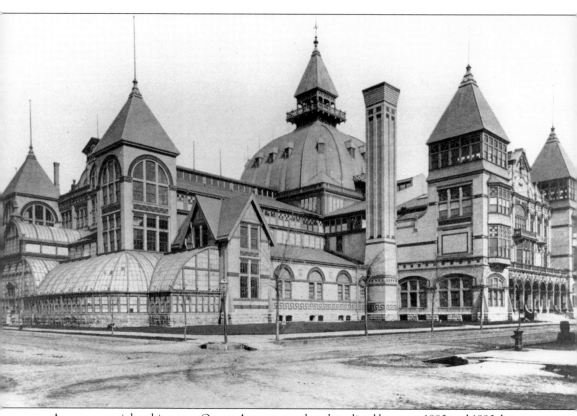

As a commercial architecture, Queen Anne was rather short lived between 1880 and 1890; however, as residences, corner shops, and taverns, the style prevailed as late as 1910. The Queen Anne style most often exhibited the expression of wood; unfortunately, given the material's vulnerability to deterioration and fire, many large-scale Queen Annes have been lost or significantly remodeled by use of modern materials. Queen Annes drew inspiration from the 17th- and 18th-century rural architecture of Tudor England in a "free-form" manner, allowing for considerable variation and personal interpretation generally recognized by their colorful, irregular silhouettes, multi-pitched roofs, chimney stacks, varied surface texture, and round or polygonal turrets. In the spirit of grand convention halls, the Industrial Exposition Center was created in 1881 along Kilbourn Avenue between North Fifth and Sixth Streets on a parcel of land originally allotted for public use by Byron Kilbourn. Edward Townsend Mix designed the massive, rambling Queen Anne structure in the epitome of the style. Unfortunately, the Industrial Exposition Center was destroyed by fire in 1904. (Courtesy of Historic Photo Collection/Milwaukee Public Library.)

A notable departure from the carved stone facades constructed only four years previous across the street, the James Conroy Building exhibits Queen Anne commercial architecture in all its glory. Constructed of red and brown brick with abounding surface texture, bay windows, and considerable height, the building was added to North Milwaukee Street's 700 block in 1881 housing an ice cream parlor at ground level. (Courtesy of Milwaukee Historic Preservation Commission.)

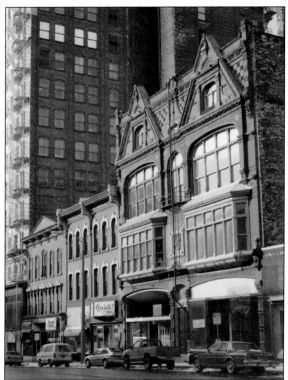

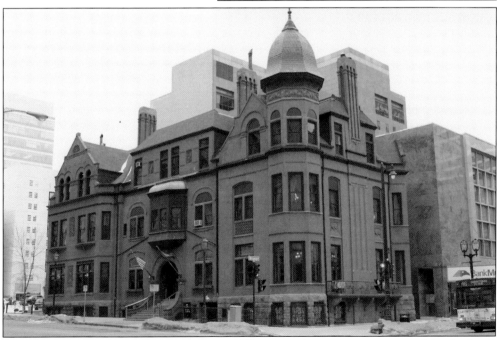

The Milwaukee Club at Jefferson Street and Wisconsin Avenue remains one of the few brick buildings constructed in the Queen Anne style. The clubhouse was erected for the businessmen's social club founded in 1882. Silsbee and Kent of Chicago designed the red brick clubhouse in 1884 with sunburst motifs and a polygonal turret characteristic of the Queen Anne style.

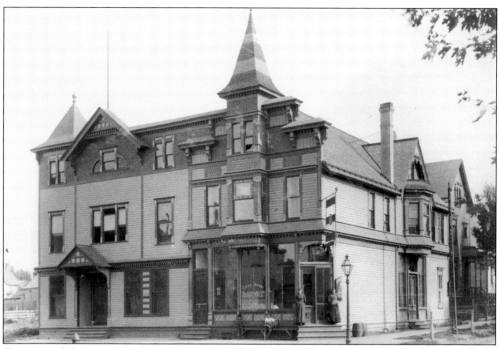

Commercial Queen Annes were more commonly constructed as corner establishments integrated into residential districts. Pabst Brewery erected Metropolitan Hall around 1890 according to the designs of architect Otto Strack with Queen Anne influences, a style uncharacteristic for Strack. (Courtesy of John Steiner.)

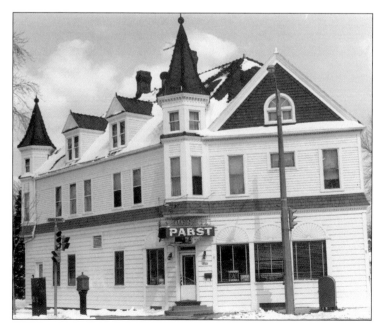

William Kneisler's White House, a supposed watering hole for local politicians, was constructed in 1890 shortly after the City of Milwaukee annexed the village of Bay View in 1887. The tavern stands at an unusual intersection with a pentagonal plan, shingled gables, turrets, and sunburst motifs. (Courtesy of Milwaukee Historic Preservation Commission.)

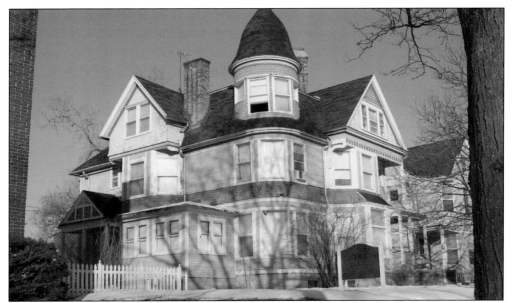

James Douglas designed an exuberant Queen Anne residence for Judge William J. Turner in 1887. Located in the West End neighborhood, Turner was one of many influential professionals to relocate in the prestigious neighborhood between 1870 and 1910. Turner's residence exemplifies the hallmarks of Queen Anne architecture with multiple pronounced gables, projecting bay windows, textured surface treatment, immense proportions, and a corner tower anchoring the so-called "castle of wood."

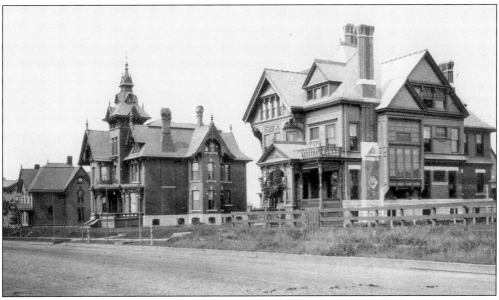

Prospect Avenue had become a prominent mansion address by the late 1870s with an array of fine Victorian homes. During the 1880s and 1890s, the avenue was deemed the "Gold Coast," rivaling the mansions of Wisconsin Avenue with quintessential Queen Annes like the Sanford Kane residence (right). Also designed by Douglas in 1883, the Kane residence is one of the best preserved Queen Annes of its caliber and size. (Courtesy of Historic Photo Collection/Milwaukee Public Library.)

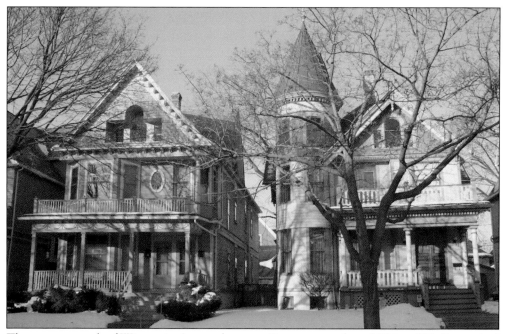

The avenues north of Wisconsin Avenue between Twenty-seventh and Thirty-fifth Streets had recently been annexed by the city. Referred to as the West End, the neighborhood experienced a similar development between 1880 and 1910, accounting for its concentration of Queen Anne residences. These ladies exhibit simpler renditions of the style mostly focused on the gable and window treatment.

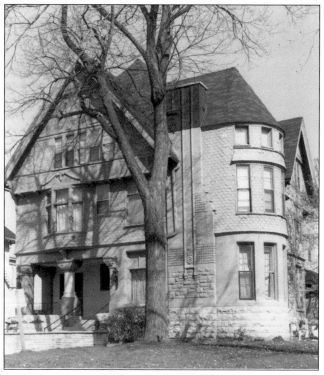

This Romanesque and Queen Anne influenced house was constructed for George Heineman in 1887 along the east side of Prospect Avenue near Brady Street. The home was designed by Henry C. Koch at the peak of mansion construction along the thoroughfare. Heineman's residence was one of the many residences along Prospect Avenue razed to make way for large luxury apartment buildings. (Courtesy of Milwaukee Historic Preservation Commission.)

The Elizabeth Plankinton Mansion, one of many constructed along Grand (now Wisconsin) Avenue between 1880 and 1890, never housed its intended occupants. Again designed by E. T. Mix, John Plankinton commissioned the Richardsonian Romanesque home as a wedding present for his daughter in 1886. Following her abruptly ended engagement, Miss Plankinton refused the home, which was later occupied by the Knights of Columbus until its demolition in 1980 for Marquette's Alumni Union. (Courtesy of Milwaukee Historic Preservation Commission.)

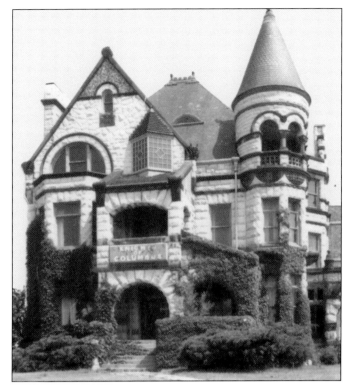

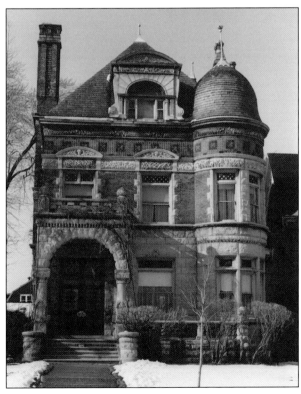

Amongst its elegant and delicately proportioned neighbors at Prospect and Juneau Avenues, the George P. Miller residence digresses with heavy massing, low sprung arches, and a helmet dome attributed to the influences of Richardsonian Romanesque and Timothy Champman's "German sentimentality." Department store owner T. A. Chapman commissioned the home in 1887 as a wedding present for his daughter Laura and son-in-law George.

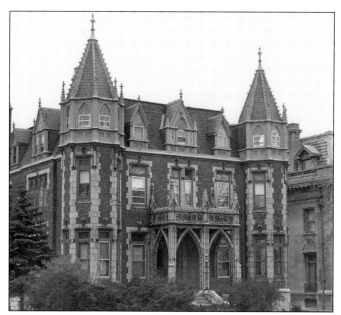

Abandoning the distrustful air between Yankees and Germans, Milwaukee native William Osborne Goodrich married Marie Pabst. The Goodrich home was designed by Pabst's supervising architect, Otto Strack, as a showplace of the ever-returning French Gothic style. Built in 1893, the home was constructed just before the heyday of development along the bluff on Terrace Avenue. (Courtesy of Milwaukee Historic Preservation Commission.)

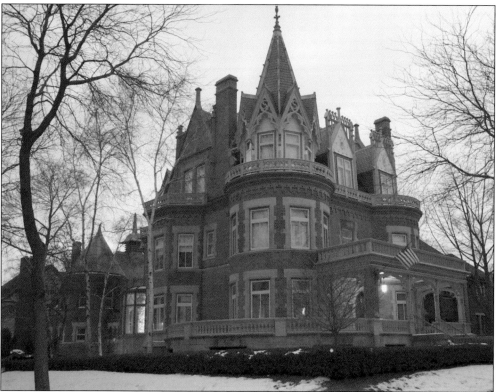

Gothic inspired architecture is a ubiquitous creature that continually evidences itself without precedence, each time a little more extravagant than the last. After the original owner went bankrupt, George Martin Jr. purchased the unfurnished home and completed it to the original plans in 1898. The impeccable, flamboyant French Gothic Chateau was the first constructed along Newberry Boulevard.

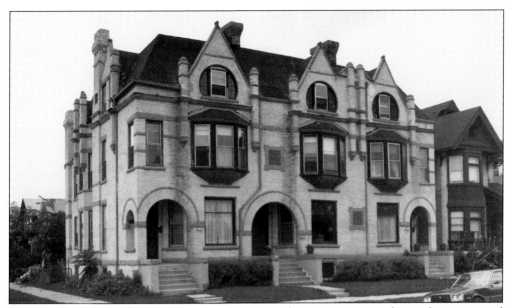

Between the 1880s and 1890s, several multiunit row houses were erected near downtown and Yankee Hill. Popular in New York and New England, row houses were uncommon in Milwaukee, as free-standing homes were especially affordable until the turn of the 20th century when available land surrounding the central business district became limited and thus expensive. Graham Row (above) was constructed in 1887 by Ireland native and builder John Graham as an income property. Graham's construction company had gained considerable success since the founder's arrival in 1847, constructing such buildings as Chapman's department store, Pabst Theater, and St. Paul's Episcopal Church. Likewise an investment property, Friedmann's Row (below) was constructed in 1891 for Jewish Austrian immigrant Ignatius Friedmann. A common fate for Milwaukee's row houses, Friedmann's Row became rooming houses during the Great Depression, deteriorating until its restoration in the 1990s. (Below, courtesy of Milwaukee Historic Preservation Commission.)

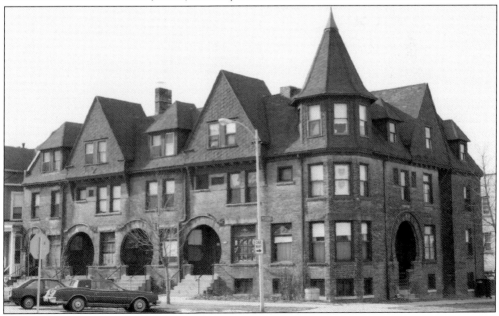

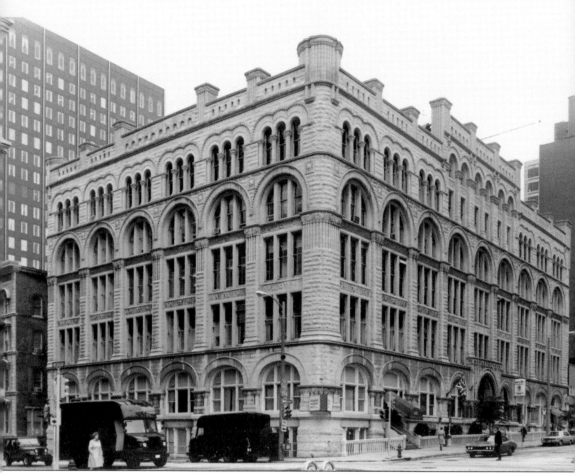

In the 1880s and 1890s, growth and transformation continued in the central business district. Less than 20 years at its previous office building, North Western Mutual Life Insurance Company's continual success and consequential growth yielded a new office building one block south of the original. Designed by Chicago architect Solon Spencer Beman, the company's new building was added to the pioneer banking district at the northwest corner of Broadway and Michigan Avenue adjacent to the Bank of Milwaukee. The colossal Richardsonian Romanesque block stands as one of the best examples of its style in the Midwest, and the best in Milwaukee, with an exquisite five-story atrium that rivals the impressive exterior. The use of the style in commercial architecture created prestigious blocks with the monumental massing and austere compositions characteristic of Romanesque designs. Moreover, Richardsonian Romanesque omitted the complex rooflines and abundant surface ornament characteristic of most Victorian architecture, alluding to the simplified styles of architecture to follow. (Courtesy of Milwaukee Historic Preservation Commission.)

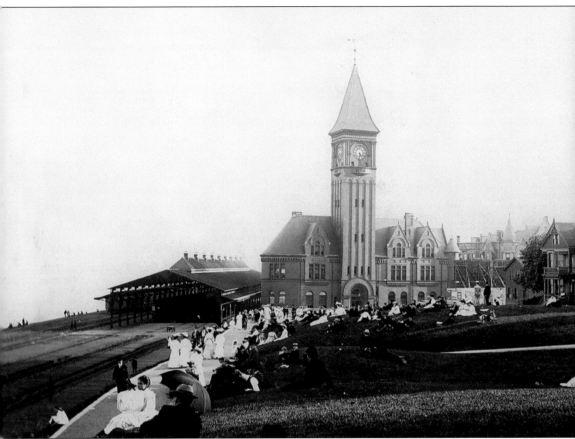

As the number of trains increased per day, the number of commuters and visitors increased as well. In due time, Milwaukee's first major railroad station, Union Depot, was outgrown. Moreover, both the Milwaukee Road and the Chicago and Northwestern Depot increased their termini, and no longer needing to meet under one roof, the two rail lines vacated Union Depot for their own stations. Charles Sumner Frost of Chicago used Richardsonian Romanesque influences in the design of the new Chicago and Northwestern Railroad depot erected in 1889 at the east end of Wisconsin Avenue on the lakefront. Like other grand and prestigious railroad depots, the Chicago and Northwestern Station was viewed as the gate to the city, offering incoming visitors their first impression of Milwaukee. The passenger station's relocation to the east end of Wisconsin Avenue spurred the construction of several hotels in order to accommodate incoming tourists. (Courtesy of Historic Photo Collection/Milwaukee Public Library.)

After Union Depot was vacated, Walker's Point's main commercial district shifted to South Fifth Street nearer National Avenue. Consequently, much of the commercial development along South First and Second Streets gave way to light manufacturing. Having developed during the late 1880s and 1890s, South Fifth Street contains a unique concentration of Victorian Romanesque and Queen Anne influenced commercial buildings such as the Trock Building, erected in 1885.

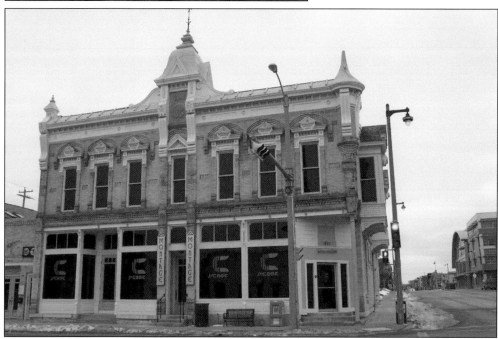

Commercial activity along South Second Street likewise moved closer to National Avenue at a crucial streetcar turning point. Grocer Frederick Bahr erected the district's most flamboyant Queen Anne block at the southwest corner of National Avenue and South Second Street in 1887. Following his death a year later, his sons continued the grocery business while living upstairs with their family. The other storefront was leased to cigar manufacturer Henry F. Fischedick.

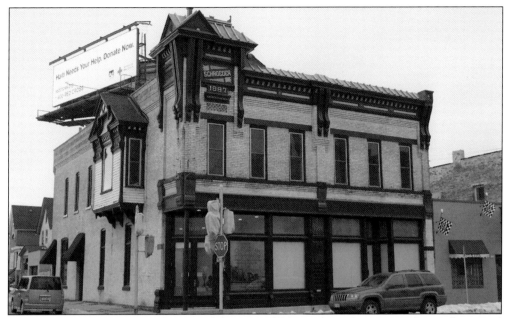

South Fifth Street was also the site of the annual Jahrmarkt, a farmers market and carnival of sorts, sponsored by the predominantly German merchants in the district. People purchased produce directly from farmers during the day while the merchants and taverns set up stands along the sidewalk distributing beer as brass bands played in the street. At the south end of the district, Frederick Schroeder erected a commercial block topped with an unprecedented corner turret displaying Schroeder's name and the date of construction (above). Like many merchants, Schroeder lived upstairs while he operated a grocery store and blacksmith shop on the ground floor. Simon Schaefer constructed a double store (below) across the street in 1891 where he operated a saloon in the north storefront, leased a series of pharmacists in the south storefront and relocated his boardinghouse upstairs.

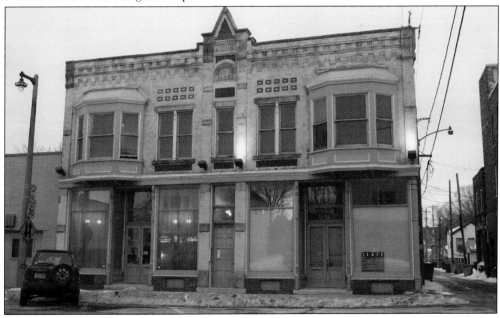

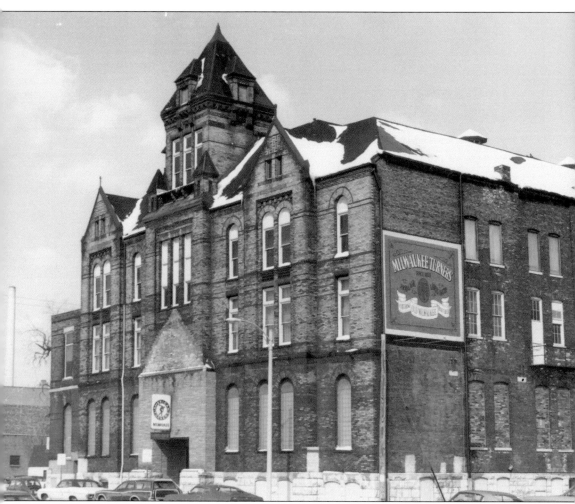

Continuing to influence the city well into the turn of the 19th century, the German revolutionaries referred to as the forty-eighters established the Turnverein in 1853 as a pursuit of social reform, physical education through gymnastics, and furthering the arts. The Turnverein was one of many institutions and cultural transformations established by the forty-eighters that would deem Milwaukee Deutsch-Athens. In 1882, Milwaukee architect Henry C. Koch designed the Victorian Romanesque Turner Hall as a center for German-American culture, a political arena, and a monumental civic beacon. The interior showed evidence of Milwaukee's German panorama painting with 12 murals depicting moments of the Turner movement and scenes from German villages. A similar institution was the German-English Academy. (Courtesy of Milwaukee Historic Preservation Commission.)

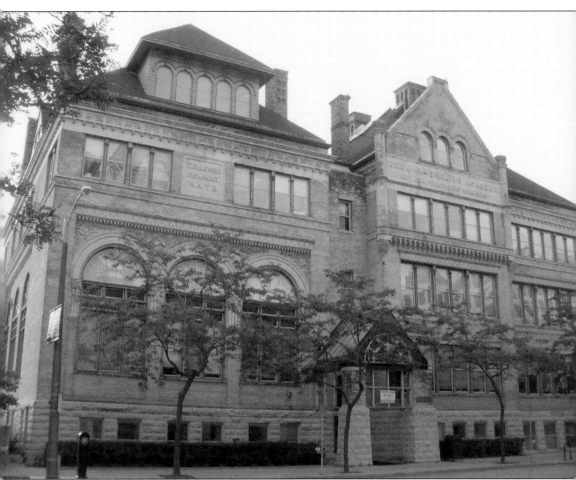

In 1851, fearing the loss of cultural identity and language, as public school curriculum did not include German, residents founded the Milwaukee Schulverein (the Milwaukee Education Association) and the German-English Academy. The original school building was erected in 1853 on Broadway between Juneau and Knapp. The Academy merged with the National Teachers Seminar, a bilingual teacher training program, and the American Gymnastics Union, a training school for German-American gymnastics teachers. The current school was erected in 1891 in the Victorian Romanesque style, designed by Charles D. Crane and Carl C. Barkhausen. Built in honor of tanning magnate Guido Pfister, the school was donated to the association by his wife and daughter. The Gymnastics Union erected the adjacent building the following year and the two buildings were thus joined. In 1900, the German-English Academy was praised for its educational standards and was a model for the public schools. The academy was renamed the Milwaukee University School during World War I on account of the anti-German sentiment that ensued and eventually moved to River Hills.

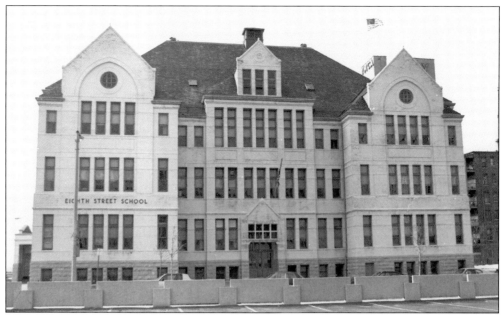

With the adoption of the City Charter in 1846, a free public school system was established placing one school in each of the five existing wards. Between the 1880s and 1890s, Henry C. Koch designed five Victorian Romanesque school buildings. The third Eighth Street School building (above) was erected in 1884 to replace the previous school built in 1857. The Fourth Street School (below) currently named for alumnus and former prime minister of Israel Golda Meir was built in 1890 on the site of the previous school building. The detailing of the facade reflects the prosperity of the neighborhood and, referencing the heirs of the Schlitz Brewery with an owl, the Uihlein family symbol. The area near Fifth and Galena Streets was referred to as Uihlein Hill for the cluster of Uihlein family homes. (Above, courtesy of Milwaukee Historic Preservation Commission.)

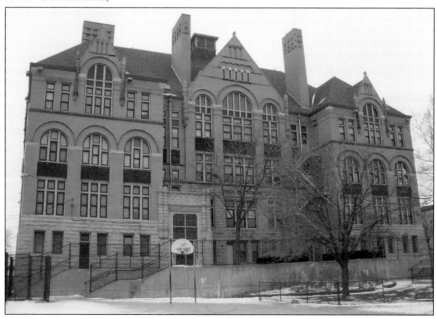

By 1890, the small breweries along Brewery Row had closed or merged with Pabst, Schlitz, or Blatz. As breweries decreased, competition rose and between the late 1880s and 1907, breweries constructed saloons that were leased to proprietors who sold the brewery's product exclusively. Frank Druml's Pleasant House was built by Schlitz Brewery in 1890 adjacent to Gallun Tannery. (Courtesy of Milwaukee Historic Preservation Commission.)

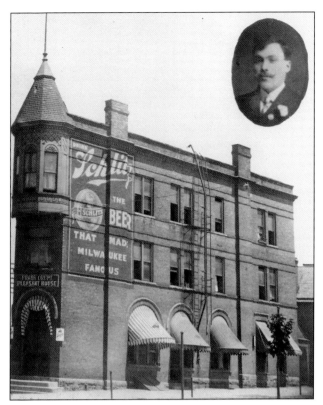

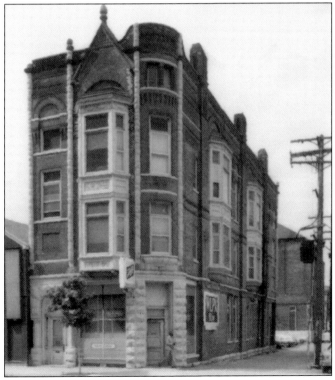

At the beginning of the brewery-built saloon era, Schlitz Brewery erected a Victorian Romanesque saloon near Third and State Streets in 1889 designed by Schlitz patron architect Charles Kirchoff Jr., combining the ornate nature of Victorian architecture and the heavy massing of Romanesque. Anton Kuolt, the German-born proprietor, operated the saloon while living on the second floor and renting the third floor as a public hall. (Courtesy of Milwaukee Historic Preservation Commission.)

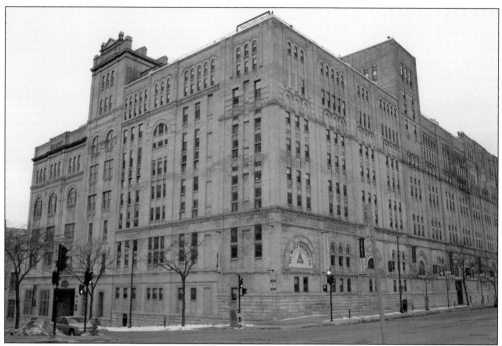

Around the 1880s, large companies began to buy out their smaller counterparts, consolidating the number of businesses while increasing production and output. Likewise during this period, many of the breweries continued the expansion of their complexes. Blatz brewery complex was revamped with its towering Romanesque buildings between 1890 and 1910. Bavarian native Valentine Blatz was originally the brewmaster for the John Braun brewery producing a German-style lager. Blatz later married Braun's widow and assumed control of the brewery under his own name in 1852. By the 1870s, Blatz Brewery was one of the first Milwaukee breweries to ship its product nationwide.

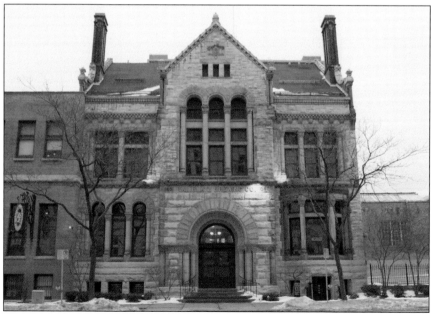

The imposing Richardsonian Romanesque block along West Wisconsin Avenue was deemed the Federal Building, originally housing the Post Office, Federal Court, and Customs House in Milwaukee. Constructed between 1892 and 1899, the massive building was designed by Willoughby J. Edbrooke, mimicking the design of the Allgheny County Courthouse and Prison designed by Henry Hobson Richardson, originator of the style, with a steel skeletal structure hinting toward the subsequent age of structural steel skyscrapers. (Courtesy of Milwaukee Historic Preservation Commission.)

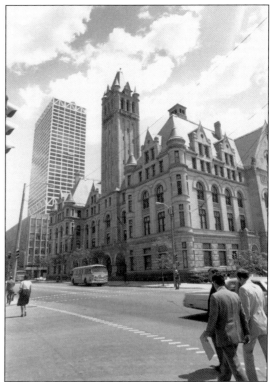

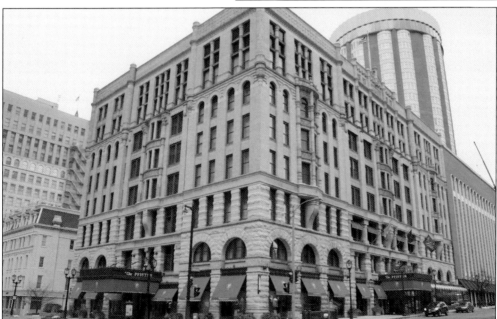

Likewise built in honor of German tanning magnate Guido Pfister, Henry C. Koch designed the Pfister hotel in a "modernized" version of Richardsonian Romanesque incorporating Wauwatosa limestone and cream city brick. Although Guido Pfister was unable to fulfill his aspiration of opening Milwaukee's first luxury hotel prior to his death, his son Charles and department store owner Timothy Chapman partnered to construct the Pfister Hotel in 1893.

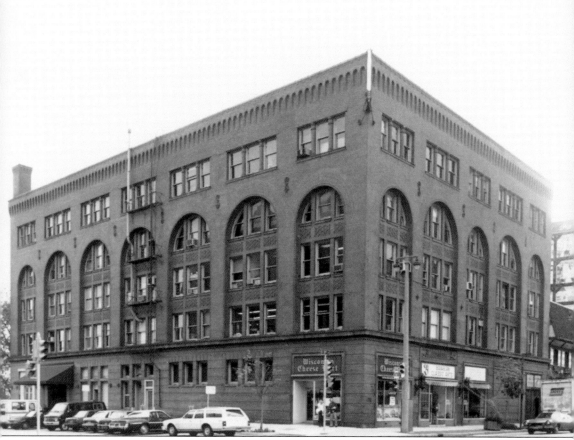

Departing from the highly decorative, whimsical Victorian architecture, the sober Romanesque Revival had begun the return to restraint, symmetry, and ordered clarity. Steinmeyer's Romanesque Revival block was designed by architects George Ferry and Alfred Clas, marking the final phase of North Third Street's commercial development. The business was established as Steinmeyer and Bauer Wholesale Grocery in 1865, but William Steinmeyer later bought his partner's share of the business. A successful grocer, Steinmeyer opened a second store on the south side at South Second and Mineral Streets in 1880. The merchant experienced considerable success until his death in 1892, at which time Steinmeyer Wholesale Grocery was passed on to his brother Charles and son-in-law Emil Ott, who continued William's plan to erect the large masonry block in 1893. A precursor to the super market, the Steinmeyer Company employed order takers and delivery drivers, who delivered goods until 1940. (Courtesy of Milwaukee Historic Preservation Commission.)

Five

VICTORIAN FOLK ARCHITECTURE

City records indicate that Polish immigrants had arrived as early as 1842; however, it was not until after the Civil War that a sizable population immigrated to Milwaukee in 1866. Previously in 1795, the Polish state had been divided and occupied by Austria, Russia, and Prussia. Coincidentally, 88 percent of the Poles immigrating to Milwaukee were native to the German occupied region of Poland, which was notoriously poor, and harbored considerable resistance against the Polish language and culture. Spurred by a failed revolt against occupying forces in 1863, Polish immigrants flooded to Milwaukee for economic and political relief. While seemingly contradictory for the Poles to inhabit a region so saturated with Germans, it provided them with opportunities to communicate and likely played a role in the Polish community's fervor for preserving their native language and culture. Moreover, these immigrants were less prosperous and unskilled in comparison to their German counterparts but arrived in Milwaukee at the cusp of its mounting industrial era, affording the Polish farmers with an abundance of entry-level jobs in the city's burgeoning foundries, mills, tanneries, and other manufacturing professions. Out of the labor class, merchants emerged to serve fellow residents of their industrial communities. Preferring to settle the sparsely populated, undeveloped edges of the city rather than assimilate themselves in the central districts, a large number of Polish immigrants settled the undeveloped real estate stretching along Mitchell Street on Milwaukee's south side as well as the region north of Brady Street to the Milwaukee River, both having been sparsely populated until the poles' arrival. By the 1880s, Milwaukee's Polish community was the second-largest immigrant population next to the Germans. Similar to the pioneer age, Victorian folk architecture was constructed without master builders or architects, erecting buildings out of necessity and functionality with limited means. Basically creating a working-class version of the Queen Anne style, simply constructed buildings were ornamented with Queen Anne–style millwork and designs. Either occurring as vernacular development or because the neighborhoods developed largely between 1880 and 1920, interesting similarities traverse Milwaukee's polish neighborhoods particularly between Brady Street and Riverwest that experienced less commercial development.

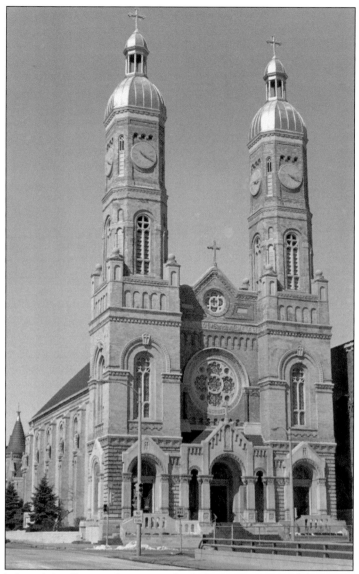

Despite knowledge of the German language, the Poles were estranged from other residents by language and cultural barriers, opting to settle in undeveloped enclaves at the city's edges versus assimilating into existing neighborhoods. In 1866, the first urban Polish parish, St. Stanislaus, found its home in a previously German church at South Fifth and Mineral Streets in Walker's Point, but by 1872, the young parish was able to build its own church to accommodate the growing number of congregants residing in the Polish neighborhood on Milwaukee's south side. The construction of St. Stanislaus Cathedral at the intersection of South Fifth and West Mitchell Streets just south of Walker's Point established Mitchell Street as a major center of activity for the Polish community. Despite being rather impoverished, St. Stanislaus' congregants were able to erect one of the city's most recognizable churches, exhibiting influences from Eastern European Romanesque churches. In the 1960s, St. Stanislaus underwent a significant restoration project. Though the historical significance of the church was preserved, alterations were made. Note the difference between the current towers and the original towers visible in the following image. (Courtesy of Milwaukee Historic Preservation Commission.)

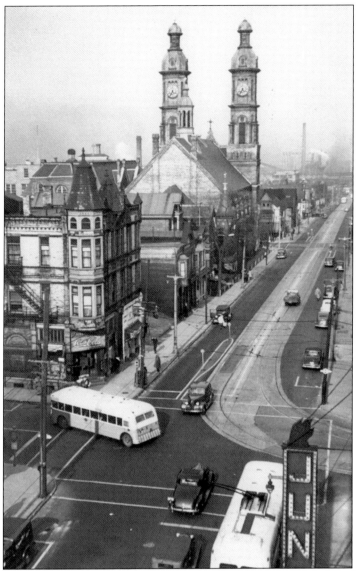

While Mitchell Street had existed since 1857 as a connection between the Janesville Plank Road and Walker's Point, it was only sparsely inhabited until the 1870s when it became lightly developed with wood frame buildings of Polish merchants serving the Polish-American community, otherwise known as "Polonia". The thoroughfare would develop to be the second most important shopping district in the city next to downtown, featuring stores like Kunzelmann-Esser's Furniture store, Goldman's department store, and Schuster's multiple theaters, and small personally owned shops, consequently earning a reputation as the "Polish Grand Avenue." The majority of development happened between South Fifth and South Thirteenth Streets from the 1880s through 1920 and continued to thrive as a shopping district well into the 1950s, at which time the local shopping district began to decline with the introduction of supermarkets, shopping centers, discount department stores, and auto-oriented shoppers. As it stands, Mitchell Street represents a turn-of-the-19th-century thoroughfare after the majority of its initial development from the 1870s and 1880s was replaced or significantly modified from its original appearance. (Courtesy of Historic Photo Collection/Milwaukee Public Library.)

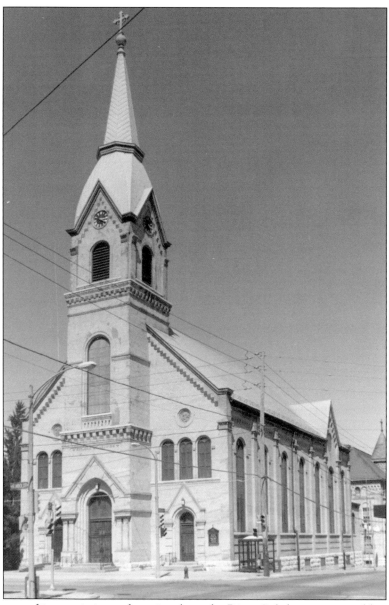

Likely because of its proximity to factories along the River, Polish immigrants likewise settled the veritable no man's land of swamp just north of Yankee Hill between Brady Street and the Milwaukee River. City directories indicate inhabitants were present before 1847, but the area did not see much growth before the Civil War, developing at large between 1875 and 1915. In 1871, a number of parishioners from St. Stanislaus formed a second congregation, St. Hedwig's, near the burgeoning Polish community north of Brady Street. St. Hedwig's stood as the center of the district in terms of its role in the community and its placement at the highest ground in the middle of Brady Street, looking over the street the way a village church would over look the village. While the current 1886 church designed by Henry Messmer exhibits hints of Victorian Romanesque in the peaked entrance porticos and transept roof, the central brick tower is reminiscent of those found in 18th and 19th century Eastern Europe, indicative of the Polish community it served. (Courtesy of Milwaukee Historic Preservation Commission.)

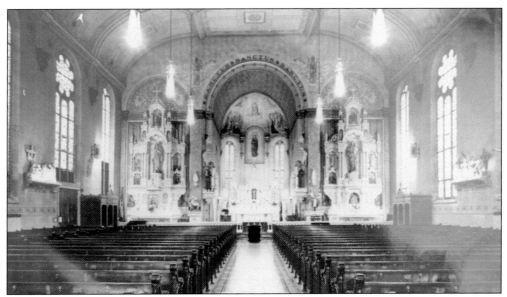

Aside from administering to the religious well being of Brady Street residents, St. Hedwig's was established in order to preserve the Polish language and culture. For over 60 years, services were conducted in the Poles' native tongue until the first English language service was held in 1933. Unlike the exterior, which stands practically unchanged, the interior of the church was significantly altered from the image shown above around 1951. (Courtesy of Milwaukee Historic Preservation Commission.)

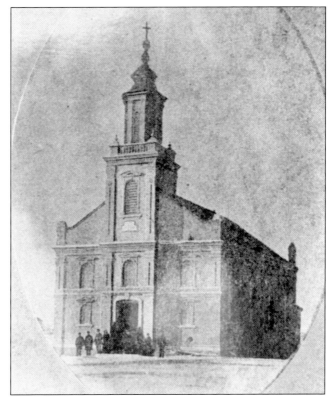

The original St. Hedwig's Church had been constructed in 1871 mostly by the hands of its parishioners on the site of the current St. Hedwig's School just east of the current church. A similar central tower with bulbous spire dominated the facade while the brick veneer exterior exemplified simple Renaissance designs with its pedimented window enframements and segmentally arched entrance. (Courtesy of Milwaukee Historic Preservation Commission.)

The village-like character of the neighborhood's narrow, winding streets densely lined with worker's cottages and narrow duplexes is owed to its Polish residents, as is the mixing of commercial and residential buildings, which differed from German and Anglo-American neighborhoods with designated commercial and residential districts. The neighborhood's development over several decades and adaptation as needs changed—with buildings varying in age, style, and form—created little architectural uniformity. In addition, aside from St. Hedwig's, the area's early construction is void of architect-designed buildings, predominantly for a lack of Polish-trained architects or master builders, as the Polish who came to the area were mostly immigrant farmers and laborers fleeing occupied Poland.

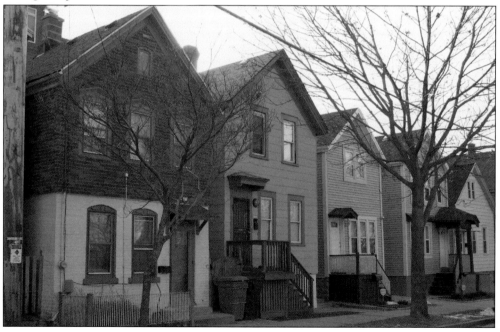

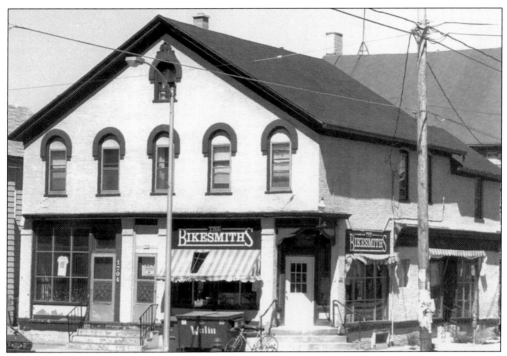

The two-story Italianate brick building at the northeast corner of Brady and Franklin Streets (above) was erected in 1874 for Charles Sikorski. Presumably the first brick commercial building in the neighborhood, Sikorski's was constructed across from St. Hedwig's in the heart of Brady Street's social activity. An unusual example of frame commercial architecture, the twin two-story gabled buildings at 1301-1307 East Brady Street were originally built as two separate buildings in 1881 and 1882 and connected previous to the turn of the century. The simple exteriors are thought to be nearly original. (Both, courtesy of Milwaukee Historic Preservation Commission.)

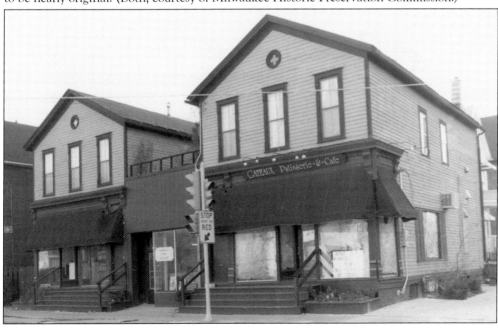

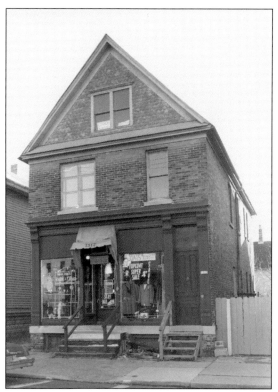

Initially Brady Street developed for working class residents employed by the neighboring manufacturers and tanneries but slowly gave way to commercial business. The original German merchants in the neighborhood were replaced by Polish laborers turned merchants in order to serve the Polish speaking community conducting business in the Polish language. As needs changed, the buildings along Brady Street were adapted instead of being replaced. Originally a wood frame building, the commercial structure at 1315 East Brady Street (left) was underpinned with a brick foundation and brick veneer as well as a large addition to the rear and side around 1902. (Courtesy of Milwaukee Historic Preservation Commission.)

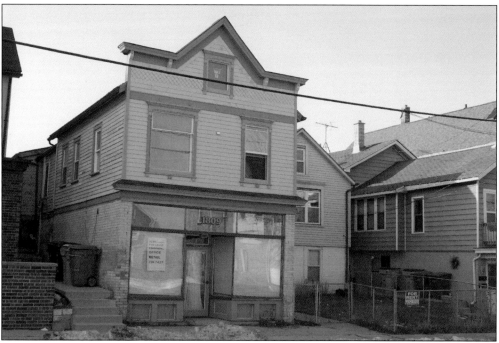

Often the first floor of merchants' homes were renovated into storefronts with proprietors' apartments upstairs creating an unusual mix of residential and commercial buildings. Such is the case with this raised worker's cottage that was fitted with a false front.

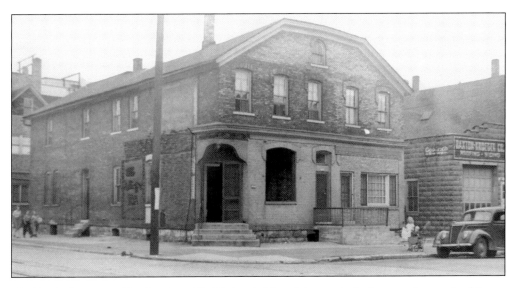

The Brady Street neighborhood and St. Hedwig's Church in particular have an interesting history of recycling outgrown buildings from the church complex. When the first St. Hedwig's school was outgrown by 1879, instead of demolishing the building, a raffle was held with the building as a prize to raise funds for a new building. The schoolhouse (above) was moved to the northwest corner of Brady Street and Arlington Place. The frame building was encased in brick and fitted with a rear addition. Similarly, St. Hedwig's first church rectory (below) was moved to an unusual corner, at North Hamilton and Pulaski Streets, where it still stands as a private residence along the ambling street. (Both, courtesy of Milwaukee Historic Preservation Commission.)

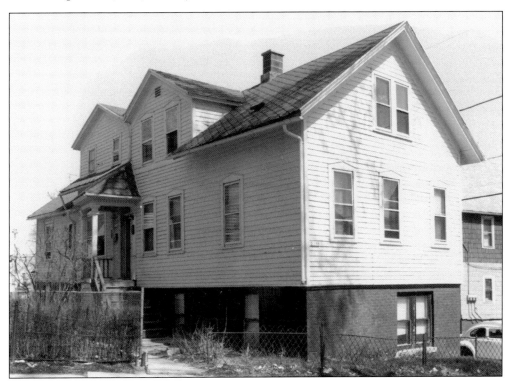

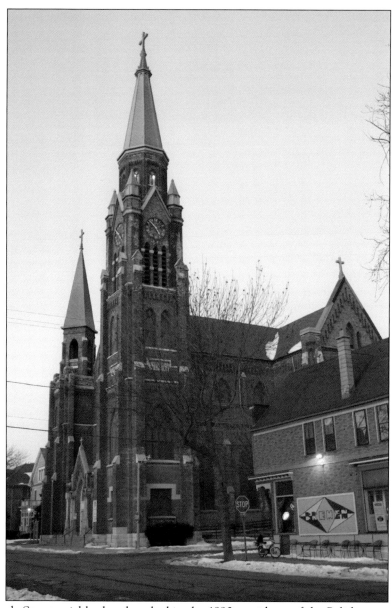

As the Brady Street neighborhood peaked in the 1890s, residents of the Polish community had migrated across the river north of North Avenue and west of the river near Humboldt Avenue, which had previously been developed with the vacation homes of German-American residents. In 1893, St. Hedwig's congregation divided, as the number of congregants living in the northwest enclave had grown enough to support another parish. A school was of great importance in the Riverwest neighborhood and was constructed the following year in 1894 according to the designs of Henry Messmer. By 1899, the congregation had doubled, affording the construction of the current St. Casimir's church designed by Erhard Brielmaier finished in 1901. St. Casimir's was constructed amidst a working-class, residential neighborhood developing between 1885 and 1915. The streets are predominantly lined with modest wood frame or brick houses interspersed with occasional storefronts and small stores or taverns located at the corner lots, similar to the establishment seen in the lower, right-hand corner built in 1895 for Frank Czsiya.

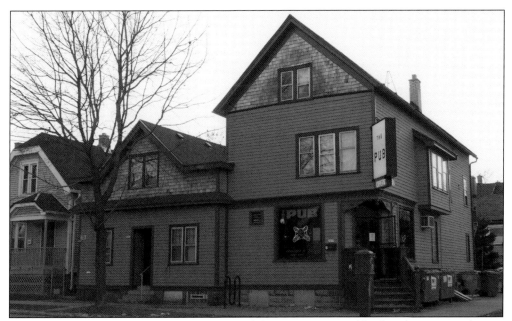

One of the most interesting characteristics of the Riverwest neighborhood is its varied array of corner establishments seemingly present at most intersections. Wood frame taverns such as this one represent those most commonly found on the south side of Center Street with a corner entrance and sparse decorative embellishments. The false front added to a small worker's cottage is likewise a common fixture, both dating around 1895.

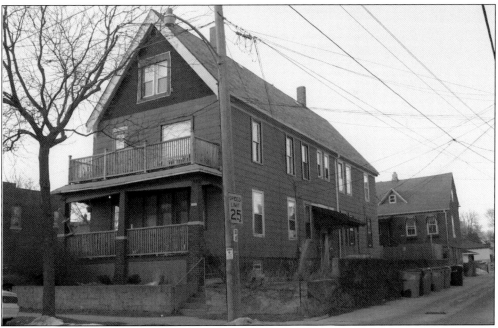

A common residential fixture in Riverwest and the Brady Street area, these simple, slender multiunit homes were seemingly constructed to house four families. Similar structures at one point contained a small commercial space in the front lower apartment. Behind the building, a small alley house is visible, most likely constructed to house a growing family.

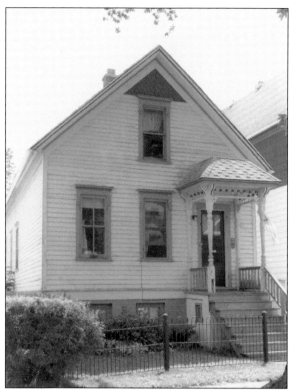

The "Polish Flat" is a term used to describe the unique residential architecture attributed to Polish immigrants in Milwaukee. The single-story, front-gabled, cottage-like homes became Milwaukee's answer to decent home ownership for working-class Polish immigrants. Without reference to European predecessors, the flat appears to be exclusive to turn-of-the-century vernacular architecture and a response to the narrow lots available and the immense population density that characterized Polish neighborhoods.

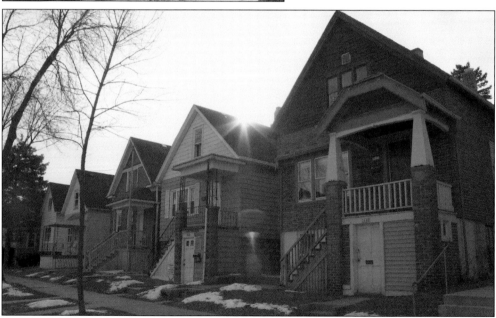

Veritable works in progress, the flats were renovated as families expanded and tastes changed rather than demolishing and starting anew. The single-story homes were often raised to construct an above-grade basement intended to function as a separate apartment with a separate entrance for renters or housing for a growing family or recently arrived relatives. The construction and renovation of these flats was most popular between 1890 and 1910.

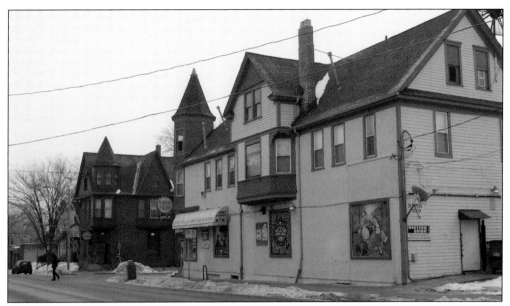

These two buildings at the intersection of East Locust and North Weil Streets, relatively intact from their time of construction, are among the best preserved commercial buildings in the Riverwest neighborhood. On the right stands a commercial building designed by Polish architect Bernard Kolpacki, constructed for Theo Beozkowski in 1893. Across Weil Street, the tavern was constructed for Leo Kaczowski in 1902.

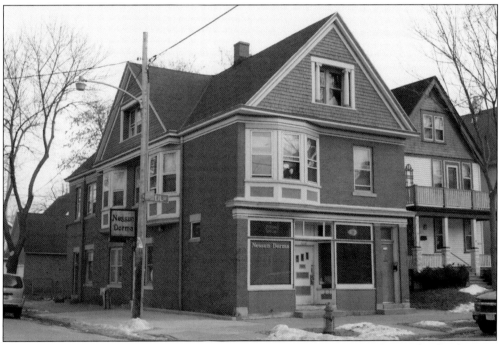

The earlier commercial structures were made of wood and exist largely on the south side of Center Street with simplified Queen Anne details or a slender turret. A handful of later establishments were of masonry construction, exhibiting shingled gables and large bay windows with residential apartments above and in the rear. These buildings stand along several blocks north of Center Street.

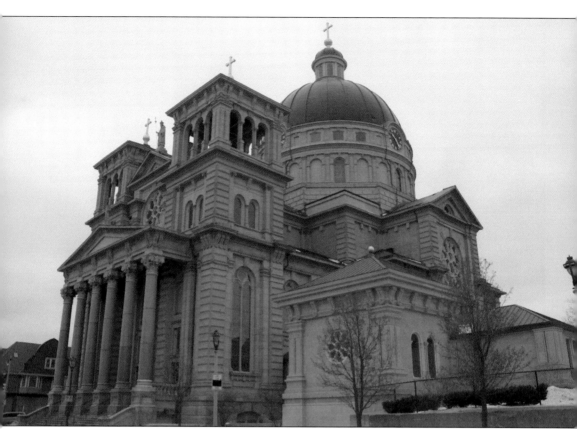

Located south of Mitchell Street on Lincoln Avenue, St. Josaphat's Basilica stands as a beacon of the Polish-American community in Milwaukee. After having outgrown its two previous churches, St. Josaphat's parish campaigned for the construction of a new church designed by architect Erhard Brielmaier. The massive basilica exemplifies Renaissance Revival designs attributed either to the peak of the Polish empire during the European Renaissance or to the ensuing American Renaissance at the turn of the 20th century. Despite the parish's working-class demographic teetering on the brink of poverty, their determination and dedication to the church made the basilica possible. Some congregants went as far as mortgaging their small homes in order to support the construction. Father Grutza acquired salvage rights to the Chicago Post Office and U.S. Customs House, and having the buildings disassembled and materials transported to Milwaukee in 500 railroad cars, Grutza cut the cost of the building by more than half. Construction of the church was completed in 1902, though it took another 30 years to finish the interior decor and murals.

Six

NEOCLASSICISM AND BEAUX-ARTS

Just as the Italian Renaissance followed the Middle Ages, so did the American Renaissance follow the Victorian Era. After the whimsical expression of Victorian architecture, Romanesque Revival responded to the peak of labor unrest and diverging social classes with restraint and sobriety, creating a bridge between the flamboyance of the Victorian era and the ordered clarity of neoclassical revival and Beaux-Arts that followed at the turn of the 20th century. Between 1886 and 1910, following the labor unrest and corrupt governments of the Victorian era, Milwaukee's road to Socialism was plagued by political turmoil in addition to suffering a deep financial recession between 1893 and 1898. Architecture returned to the premise that it could evoke social change, and nothing else spoke of civic responsibility and order more than Classical architecture. In 1890, the American frontier had officially closed, and following World War I, immigration would become severely restricted. After over a century of acquisitions and a chaotic array of ethnicities, the nation began seeking unification of its diversified parts. By 1890, immigrants and their children accounted for over 85 percent of Milwaukee's population, resulting in the city's status as "the most foreign city in the United States." Though the Germans and Poles held the majority, the turn of the 20th century saw an increased immigration of Eastern and Mediterranean Europeans. After the catastrophic Third Ward fire of 1892 displaced the Irish population, Italian immigrants began to settle in great density and ethnic homogeny in the vacated ward as well as the previously British neighborhood surrounding the Bay View Rolling Mill. By 1900, a population of young Greek bachelors had settled north of downtown, Serbians in Walker's Point, and an Eastern European Jewish population in a previously German neighborhood between Juneau and North Avenues. Moreover, increased population lead to less available space and increased land value, causing buildings to move upward instead of outward with the development of skyscrapers. This architectural era saw the influences of Chicago architects whose designs and general ideas begin to infiltrate the Milwaukee landscape because of its close proximity and role in turn-of-the-20th-century architectural movements.

The Kroeger Brothers department store was constructed in 1901 incorporating concrete and steel into the support structure, allowing increased fenestration compared to predecessors such as Steinmeyer. The new block was constructed for the expanding store, as large department stores were on the rise. Originally the most successful dry goods merchant on the south side of Milwaukee, Herman Kroeger's department store served the Walker's Point neighborhood until 1919. (Courtesy of Milwaukee Historic Preservation Commission.)

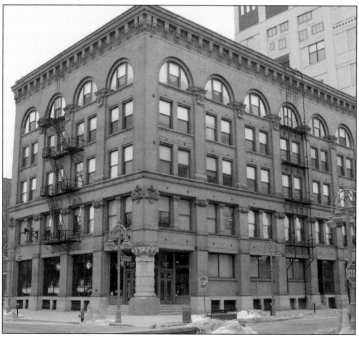

Buildings such as these in Milwaukee's flourishing wholesale district bridged the gap between heavy masonry blocks and the classicized commercial buildings soon to come. In 1900, wholesale was still listed as Milwaukee's largest business activity in the U.S. Census and remained an integral part to the city's economy until World War II and the Great Depression, when truck transport relocated most wholesale districts to the suburbs.

On October 28, 1892, the Third Ward fire wreaked havoc on the wholesaling district and the center of Milwaukee's Irish community. While most residents relocated to various neighborhoods, the Third Ward was redeveloped between 1892 and 1920, predominantly in a classicized commercial style emphasizing functionality, fenestration, and structural steel frames. Consequently the ward has the distinct aura of an intact turn-of-the-20th-century warehouse district. (Courtesy of Milwaukee Historic Preservation Commission.)

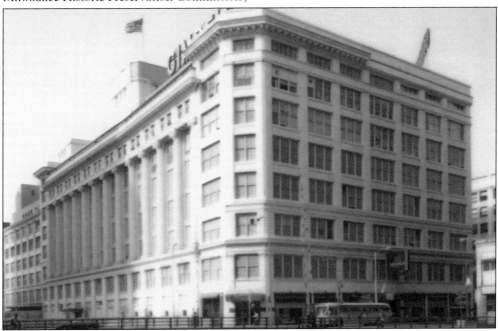

After relocating from Indiana in 1887, Gimbel's department store found its home amongst Milwaukee's downtown shopping district at the corner of Wisconsin and Plankinton Avenues. The current building is a consolidation of six structures; the first portion was designed by Daniel Burnham of Chicago between 1901 and 1902. The colossal neoclassical revival colonnade along the river was added in 1923 by Milwaukee architect Herman J. Esser. (Courtesy of Milwaukee Historic Preservation Commission.)

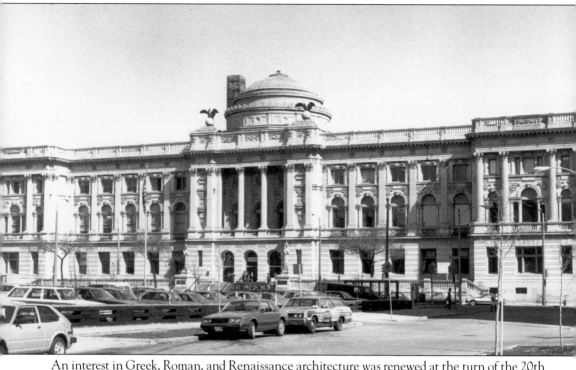

An interest in Greek, Roman, and Renaissance architecture was renewed at the turn of the 20th century, initially in Chicago, Boston, and New York. The classicized designs were manifested at the World's Columbian Exposition of 1893 in Chicago. The main exhibition, often referred to as the White City, was predominantly orchestrated by Daniel Burnham, who had requested all the buildings be constructed with white terra-cotta to create a sense of pristine uniformity and serenity. The exposition was a direct influence of architects studying at the École des Beaux-Arts in France and its program based on the Italian Renaissance and the 19th-century French architecture it had inspired. A national competition was held to find an appropriate design for the Milwaukee Public Library on Wisconsin Avenue. Champions of the neoclassical revival and Beaux-Arts styles, Milwaukee architects George Ferry and Alfred Clas received the commission based on their Beaux-Arts design. The 1898 construction was publicly funded and originally contained the Milwaukee Public Museum within the same structure until a separate facility was erected on Wells Street. (Courtesy of Milwaukee Historic Preservation Commission.)

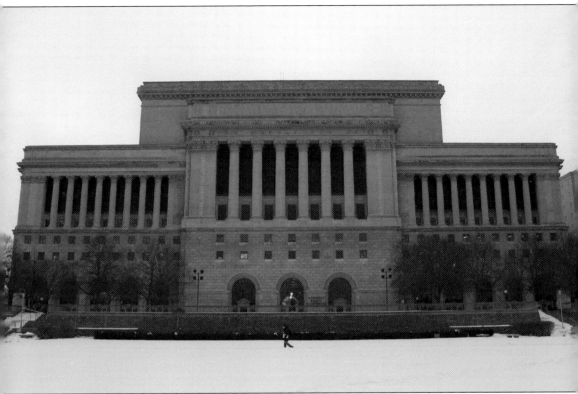

The City Beautiful Movement likewise stemmed from the World's Columbian Exposition emphasizing classicized government and civic buildings connected by grand boulevards. The City Beautiful Movement maintained the premise that classicized architecture could evoke social change, prompting civic responsibility, loyalty, and order. In 1909, Alfred Clas designed his Civic Center Project based on the theories of the City Beautiful Movement, intending to link City Hall with a new Courthouse at North Ninth Street by way of a grand boulevard, Kilbourn Avenue. The boulevard would then be lined with the city's civic and cultural buildings; however, the plan was only partially executed in the 1920s, and Kilbourn Avenue was not widened until 1941. Two decades after the Civic Center Plan was drafted, the Milwaukee County Courthouse was finally constructed in 1929, designed by New York architect Albert Randolph. Incorporating a steel frame, the monumental neoclassical revival courthouse stands stern and dignified at the west end of Kilbourn Avenue, hailed by historians and critics of the time.

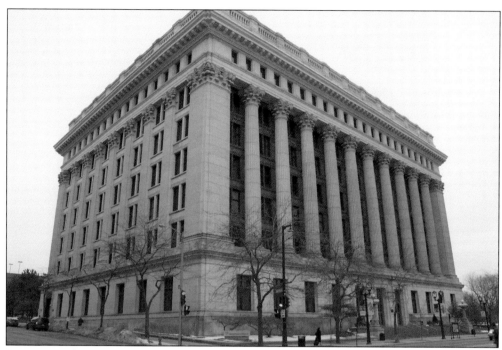

In 1914, Northwestern Mutual Life Insurance Company constructed its third home at Van Buren Street and East Wisconsin Avenue. The monumental neoclassical revival building was designed by Chicago architects Marshall and Fox with five-story fluted Corinthian Columns. Reminiscent of a Greek temple front, the imposing structure conveys a sense of strength and stability.

The First National Bank Building at the southwest corner of North Water and Mason Streets was designed by Daniel Burnham and Company between 1912 and 1914, then the largest architectural firm in the country. The First National Bank building is a 16-story, steel frame U-shaped skyscraper with neoclassical revival details. The U shape of the building creates a rear light court to allow light into the structure, a common design for large office buildings. (Courtesy of Milwaukee Historic Preservation Commission.)

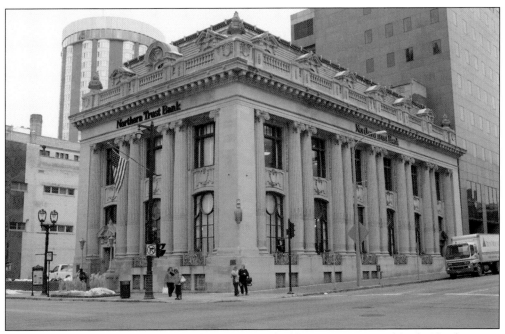

Designed by architects Ferry and Class, the Beaux-Arts building was constructed for the Northwestern National Life Insurance Company in 1906 as the third home for the company, established in 1869. The street-facing sides are dominated by a series of fluted columns, as the facade incorporates oval-shaped shields commonly found in Baroque architecture.

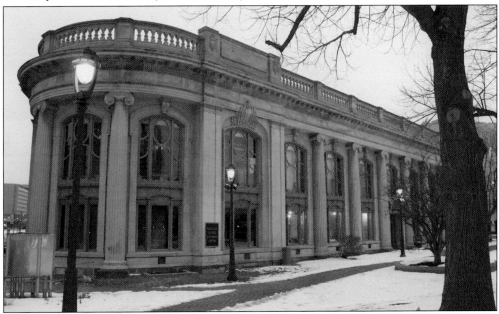

The Second Ward Savings Bank, otherwise known as the Brewer's Bank, was designed and constructed from 1910 to 1913 according to the designs of Charles Kirchoff Jr. and Thomas Leslie Rose in the Beaux-Arts style. The unusual floor plan is a consequence of Plankinton Avenue previously following the path of the river at a diagonal adjacent to the bank and terminating at State Street. The bank is now home to the Milwaukee County Historical Society.

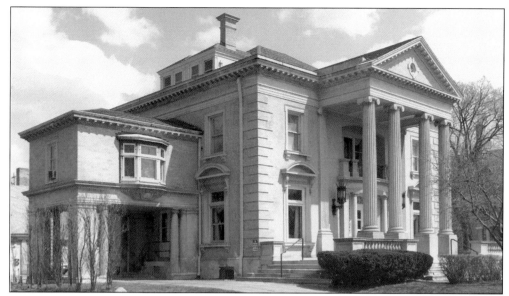

A stark departure from previous Pabst family residences, architects Fernekes and Dolliver designed one of the finest neoclassical revival residences in Milwaukee for the son of Capt. Frederick Pabst in 1897. Deemed "Sauerkraut Boulevard," West Highland Boulevard between North Twenty-seventh and Thirty-fifth Streets developed as the mansion district for German-American merchants between 1880 and 1910; however, the Frederick Pabst Jr. mansion is one of the last remaining. (Courtesy of Milwaukee Historic Preservation Commission.)

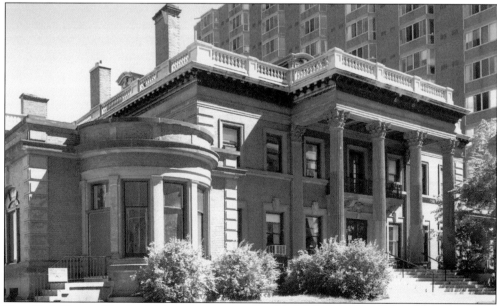

New York Native Charles McIntosh commissioned his neoclassical revival residence along Prospect Avenue in 1903, designed by Chicago architect H. R. Wilson. The home was later sold to William Osborne Goodrich, who having temporarily lost his sight at age 12 turned to music for consolation, and he leased it to the Wisconsin College of Music in 1932. The residence is currently the home of the Wisconsin Conservatory of Music, which merged with the college in 1969. (Courtesy of Milwaukee Historic Preservation Commission.)

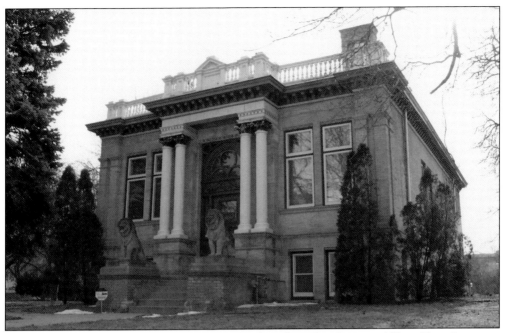

The George C. Koch residence sits along Highland Boulevard as the second "Lion House" to grace Milwaukee's streets. The home is relatively simple in plan with fluted columns and two stone lions flanking the entrance as its major embellishments. The Beaux-Arts residence was designed by Edward V. Koch in 1897, just one year after Higland Boulevard was platted.

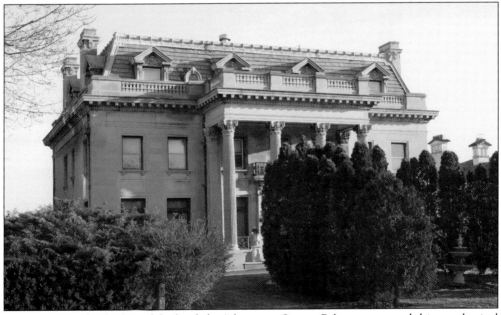

After assuming leadership of the his father's brewery, Gustav Pabst constructed this neoclassical revival mansion next door to his brother-in-law William Osborne Goodrich. The monumental columns that dominate the facade are characteristic of the style and are said to be carved from a single piece of stone. The mansion stands among many constructed by wealthy second generation industrialists in the North Point neighborhood.

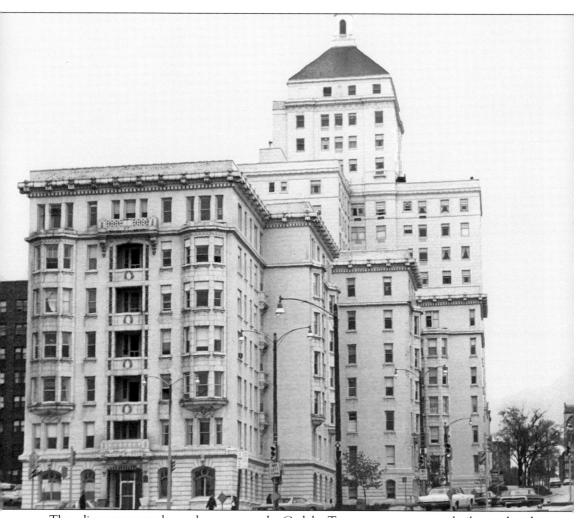

The adjacent towers that today compose the Cudahy Tower apartments were built two decades apart. Initially the six-story, eighty-three unit apartment building was referred to as Buena Vista Apartments. The pristine apartments were designed by Ferry and Clas with Beaux-Arts designs and built in 1908 and 1909 as an income property for Patrick Cudahy. The Beaux-Arts luxury apartment building initiated the transition along Prospect Avenue from mansions to apartment buildings. Twenty years later, the Cudahy Tower, designed by Chicago architects Holabird and Root, introduced high-rise apartment buildings to Milwaukee with its construction in 1928 and 1929. Cudahy Tower was designed with a series of setbacks and was clad in white terra-cotta to match its neighboring building. Over the course of the next few decades, the majority of the prestigious residences once occupying Prospect Avenue would give way to the tall luxury apartment buildings currently dominating both sides of Prospect Avenue. (Courtesy of Milwaukee Historic Preservation Commission.)

Seven

GERMAN AND FLEMISH RENAISSANCE

While cities such as New York, Boston, and Philadelphia incorporated the classicism of the Italian Renaissance and Beaux-Arts into their designs, Milwaukee redefined its vernacular architecture with the German and Flemish Renaissance as the German culture and sentiment peaked at the turn of the 20th century. While over 85 percent of Milwaukee's 1890 population consisted of immigrants and their children, the majority of these immigrants were German. The Milwaukee Sentinel declared the city to be "the most German city in the United States" in 1895, possessing more German language newspapers than English and being renowned for German industries like brewing and tanning. Between 1890 and World War I, a wave of ethnic pride swept through the city and was evidenced in a number of elaborate mansions as well as commercial buildings erected as symbols of German heritage and prosperity. The ethnic housing era was displayed most predominantly amongst wealthy German-American residents who fashioned their homes after castles and mansions of their native Germany. Most were designed by German-born architects incorporating stepped or shaped gables, bartizans and turrets, steep roofs, helmet domes, and sculptural terra-cotta figures. The German- and Flemish-inspired mansions were massive, bold, and top heavy in comparison to the subtle and austere designs of Italian Renaissance–inspired architecture. After this apex, ethnic heritage began to dissolve and blend with others by way of marriage—accelerated by the anti-German sentiment that would infiltrate the city during World War I—dismantling the German language and culture. Moreover, many of the German-inspired and ethnic residences were lost during the 1950s and 1960s as the decorative excess of Victorian architecture and the lavish German-infused mansions were seen as distasteful, the German-inspired considered to be the worst of the worst. Thus, well over a dozen were lost to Modernism, desire for a national aesthetic, and anti-German sentiment.

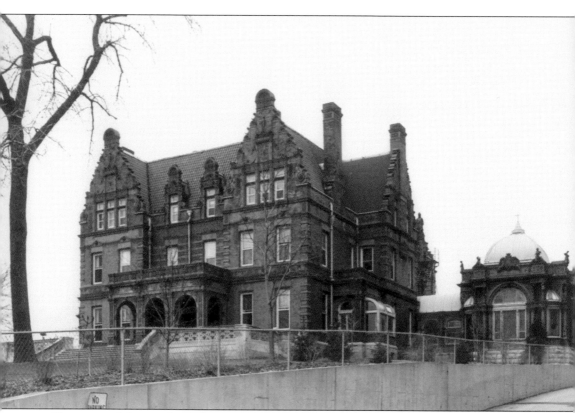

Champion of the neoclassical revival, George Bowman Ferry designed a Flemish Renaissance Revival mansion for beer baron Capt. Frederick Pabst in 1890. The Pabst Mansion's symmetrical facade differs from the majority of its successors in its elegant simplicity. The detailed stepped gables were hallmarks of the style. The delightfully articulated pavilion at the east end had been an exhibition piece in the World's Columbian Fair at Chicago discussed in the previous chapter. Situated along Wisconsin Avenue, the Pabst Mansion was once one of many lining the prominent thoroughfare. Formerly Grand Avenue, it was appropriately named for its opulent assemblage of mansions stretching from Alexander Mitchell's residence at North Ninth Street to the Harnischfeger at Thirty-fifth Street; however, the three are now among the few that remain. Initially the residents along the thoroughfare were of predominantly British ancestry, until upper class Germans began to infiltrate the avenue in the 1890s. (Courtesy of Milwaukee Historic Preservation Commission.)

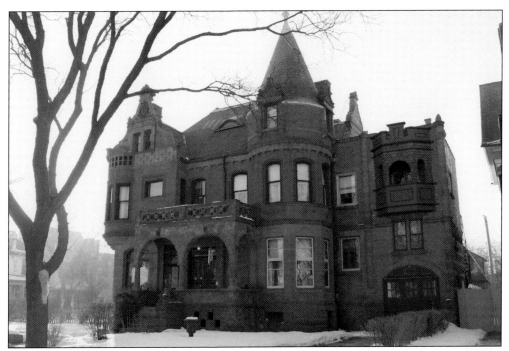

The "red castle on Wells" (above) was constructed in 1891 for George Schuster. The Ferry and Clas of German Renaissance Revival, Crane and Barkhausen, gained prominence amongst German-American clientele as Wisconsin-born Carl Barkhausen had received his architectural training in Berlin and was consequently well acquainted with the current German trends. The firm individuated the Schuster residence from its neighbors with brazen red Ohio sandstone, red brick, and orange terra-cotta. Schuster's mansion was among those constructed in the undeveloped suburban district referred to as the West End, bounded by Wisconsin Avenue and Vliet Street between North Twenty-seventh and Thirty-fifth Streets. Recently annexed in 1888, the neighborhood developed primarily between 1880 and 1910 with the residences of upper middle class German-American merchants and manufacturers. The residence for second generation German-American Abram Esbenshade (below) was likewise designed by Crane and Barkhausen in 1899.

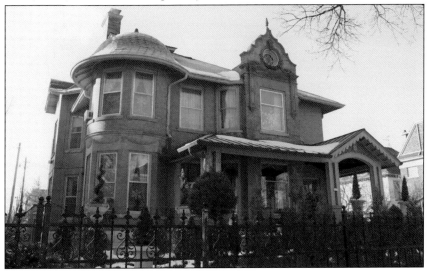

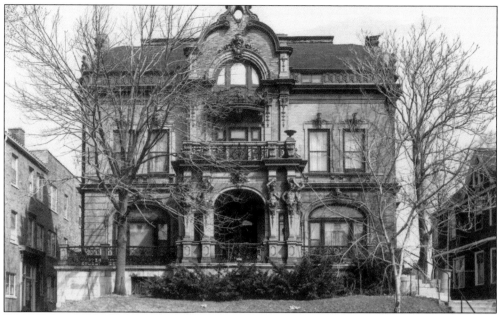

While Crane and Barkhausen seemed to specialize in German Renaissance Revival, others dabbled in German Baroque designs. In 1896, Otto Strack designed the Joseph B. Kavelage mansion (above) in designs reminiscent of 18th century Baroque palaces. A product of Strack's upbringing and training in Germany, the Kavelage Mansion is the finest manifestation of German Baroque palace architecture in the United States, exuding opulence from its curvaceous gable and atlantes or columns carved as male figures, supporting the central porch. Also German-born architects, H. Paul Schnetzky and Eugene Leibert designed the residence for wholesale wine vendor Ernst Pommer (below) with a varying degree of Baroque influence in 1895. Located in the West End neighborhood, the Pommer residence exudes a similar air of elegance with classical porch columns, a bonnet-like gable, and a helmet dome pierced by an oval oculus and attenuated with a spire. (Above, courtesy of Milwaukee Historic Preservation Commission.)

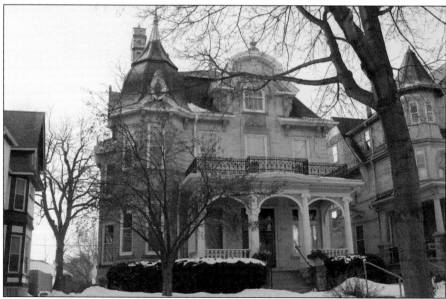

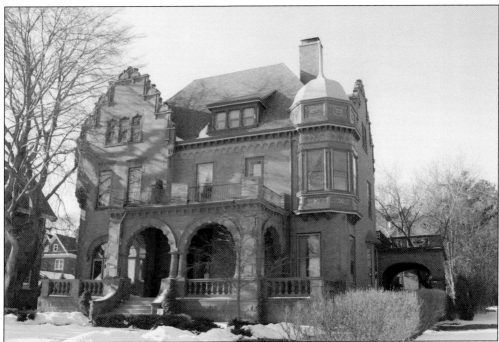

Many great residences were constructed during this period by second generation German-American heirs to their father's immigrant industries. Moreover, when John F. Kern assumed the presidency of his father's Eagle Flouring Mill in 1892 and subsequently decided to construct a new home, he naturally commissioned Crane and Barkhausen to design a German Renaissance Revival mansion (above) in 1899. Reminiscent of suburban German villas, the Kern residence was among the first to be constructed along the prestigious Wahl Avenue. Frederick Weinhagen constructed his home nearby (right), designed solely by Carl Barkhausen in 1901. Weinhagen, a German native, founded the Milwaukee Bridge and Iron Company in 1887, constructing most of the bridges downtown and operating over 100 years into the 1990s. The patterned tan and brown brick facade and highly sculptural gables are the home's dominant and individuating features.

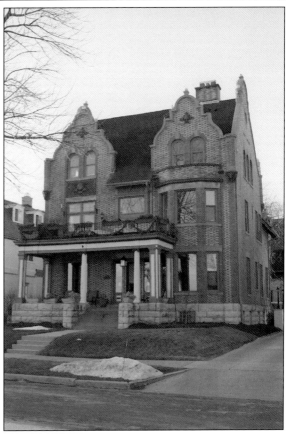

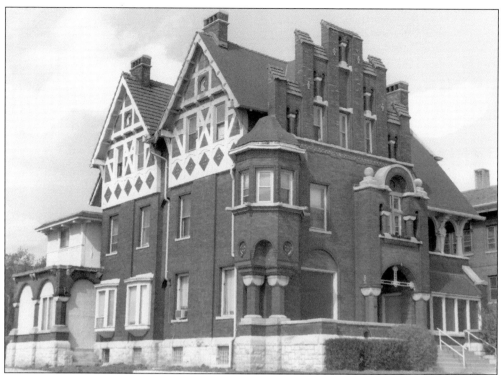

The last of the Grand Avenue mansions, the Harnischfeger Residence (above) sits at the 1888 Milwaukee city limit, North Thirty-fifth Street. The German-born manufacturing magnate arrived in Milwaukee and paved his way in Milwaukee's manufacturing industry by producing the first electric-motor traveling crane. The Harnischfeger represents a unique interpretation incorporating every nuance of German design, including timber-framed gables, stepped gable with columnar projections, bartizan, and sculptural knights standing vigilant along the second-story porch. The Gustav Trostel House (below) likewise exudes German influences of a supremely unique interpretation, coincidentally reflecting the architect's taste over the resident's. Son of tanning mogul Albert Trostel, Gustav was swayed by his brother-in-law Adolf Finkler to accept a flamboyant German hunting lodge motif. Trostel's residence was the first to stand along the north end of Terrace Avenue and remains a stark contrast from its neighbors. (Above, courtesy of Milwaukee Historic Preservation Commission.)

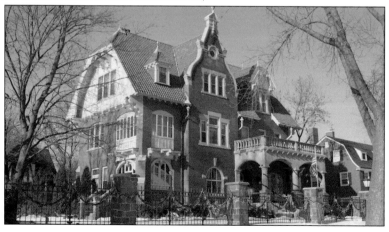

Constructed just before the heyday of development along Highland Boulevard, this rambling German-inspired residence was built by Victor Schlitz in 1890 according to the designs of Charles Gombert. Victor, the nephew of Joseph Schlitz, began a wine and liquor store on North Third Street in 1869. He lived above the store until the completion of his Highland residence.

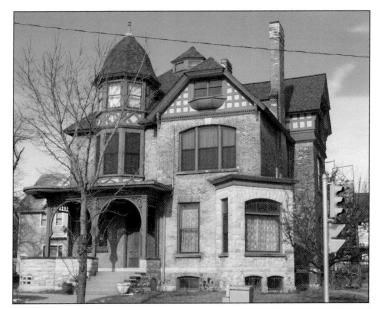

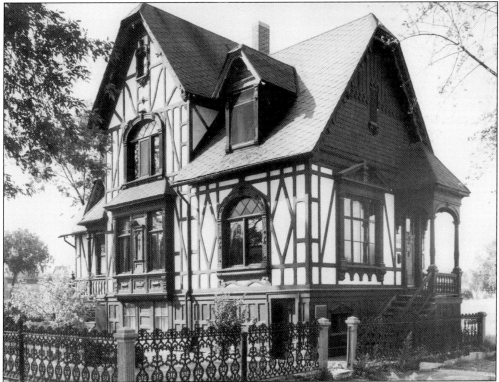

Situated a few blocks north of Highland Boulevard along North Nineteenth Street, the half-timbered home exhibits the Victorian folk architecture known to Vienna native and artisan wood carver Robert Machek. The Machek residence is reminiscent of medieval European cottages, which inspired the use of half-timbering in many of Milwaukee's German residences, and is the culmination of Machek's artistry as a wood carver, carpenter, and cabinet maker. (Courtesy of Milwaukee Historic Preservation Commission.)

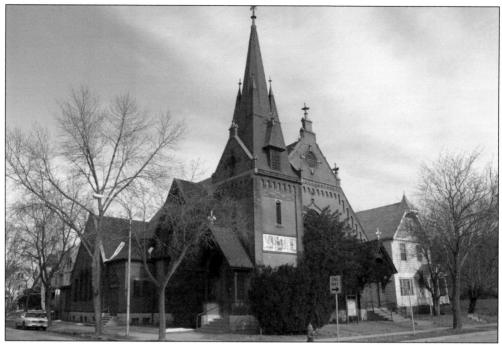

Previously the First German Methodist Church, the congregation changed its name to the Highland Boulevard Methodist Church, signifying the inclusion of English services. The rare German Gothic church was designed by Crane and Barkhausen and constructed along Highland Boulevard at Twenty-first Street in 1896 just after the thoroughfare was widened to a boulevard. The congregation's previous church was purchased by Pabst Brewery.

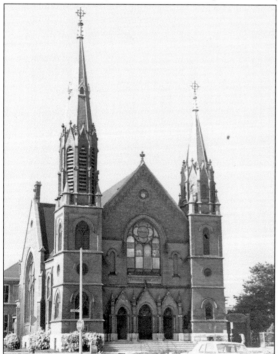

Friedens Evangelical Church's last German sermon was held in 1963. Constructed in 1905 for congregants having left Grace Lutheran Church on Broadway in 1869, the church remained a staple for its Teutonic neighborhood. Designed in a German Gothic Revival style, the church originally contained stained glass windows made in Germany, but they were destroyed by a fire in 2002. The embellished staged octagonal steeple was a hallmark of the style. (Courtesy of Milwaukee Historic Preservation Commission.)

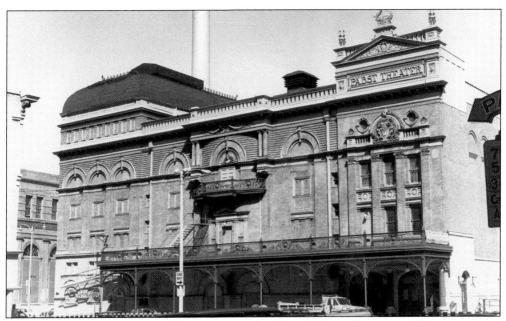

Capt. Frederick Pabst purchased the Nunnemacher Grand Opera Theater in 1890, renaming it Das Neue Stadt Theater. Unfortunately, it met an untimely demise when it was destroyed by fire in 1895. Pabst commissioned the immediate construction of the Pabst Theater. German-trained Otto Strack designed the theater in the image of European Baroque opera houses after studying the state-of-the-art acoustics and fireproofing of the Auditorium Building in Chicago. (Courtesy of Milwaukee Historic Preservation Commission.)

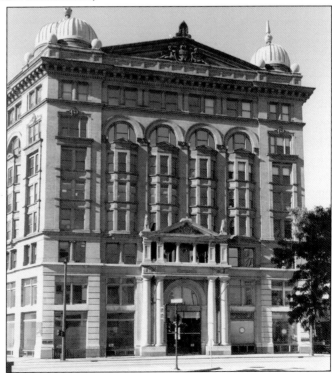

The Germania Building is predominantly a neoclassical revival office building displaying the owner's German heritage by incorporating helmet domes in the roof line, characteristic of the German Renaissance Revival style, and a statuette of Germania above the main entrance, now removed. Designed by German architects Schnetzky and Liebert, the pentagonal building was constructed for George Brumder as the national headquarters for the largest publisher of German language newspapers, Germania Publishing, in 1896. (Courtesy of Milwaukee Historic Preservation Commission.)

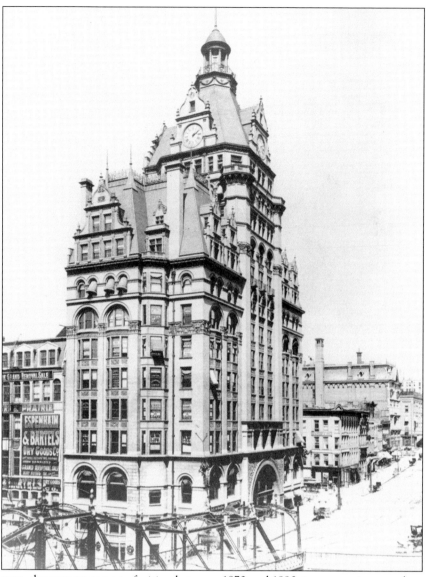

In Chicago, skyscrapers came to fruition between 1870 and 1890, incorporating metal structural frames to expand upward as land values and the need for rental space increased. Without historical precedence, architects experimented with appropriate designs for the newly developed form of architecture. Ground levels were ornamented with contemporary designs and top levels were finished with a detailed cornice, while treatment of repetitious floors baffled architects as structural steel frames reached new heights. Milwaukee's first skyscraper, the Pabst Building, was likewise a masterpiece of German-inspired architecture. The Pabst Building was an amalgamation of technology, history, and heritage. Once again the intersection at Water Street and Wisconsin Avenue was at the forefront of architectural development with the Pabst Building's construction at the northwest corner in 1892. Chicago architect Solon Spencer Beman drew influences from Richardsonian Romanesque for the base while representing Milwaukee's ethnic heritage in the Flemish Renaissance Revival gables at the top of the building. (Courtesy of Historic Photo Collection/Milwaukee Public Library.)

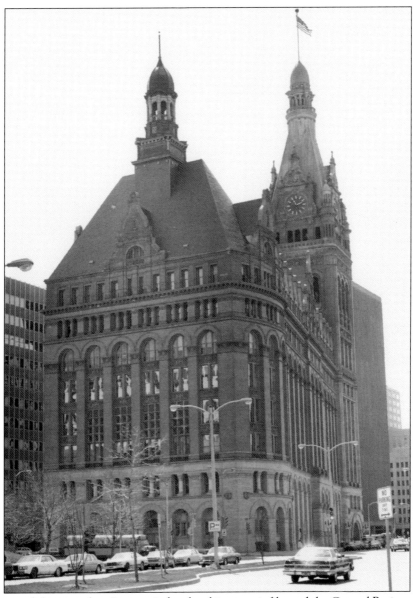

It was not until this time that German-infused architecture infiltrated the Central Business District previously dominated by mainstream designs. Initiated by the Solon Spencer Beman design for the Pabst Building in 1892, Milwaukee's new city hall followed suit shortly thereafter. Architect Henry C. Koch received the commission to design Milwaukee's city hall, a monumental German Renaissance Revival structure, drawing precedent from the Hamburg Rathaus and the neighboring Pabst Building. City hall, the third tallest building in the United States upon completion, was erected in 1895 and stood as a symbol of Milwaukee's metropolitan status, an icon of its German roots, and the evolution of its local government. The unusual shape of the building is a response to the streets that had once bounded the pioneer farmers market, as the current city hall was constructed on the same site. (Courtesy of Milwaukee Historic Preservation Commission.)

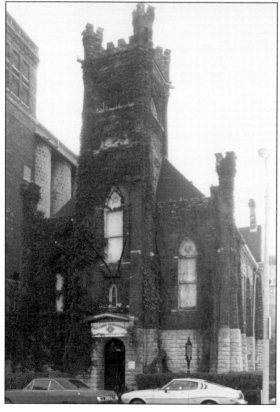

By 1874, Phillip Best Brewery was the largest beer producer in the United States under the direction of Philip Best and son-in-law Frederick Pabst. By the time the Best trademark was retired in 1889, Pabst Brewery had appropriated the area surrounding Juneau Avenue and Ninth street, the original location of Philip Best Brewery in 1844. In 1886, Pabst purchased the Jefferson Public School originally constructed in 1858 and extensively remodeled it into the Pabst office complex (above) topped with tooth-like crenellations reminiscent of medieval German castle battlements. A similar aesthetic was applied to other Pabst Brewery structures under Capt. Frederick Pabst's direction. Constructed for First German Methodist Church in 1872, the Forst Keller Restaurant (left) was remodeled by Pabst in 1898, replacing the steeple with a crenellated tower. (Left, courtesy of Milwaukee Historic Preservation Commission.)

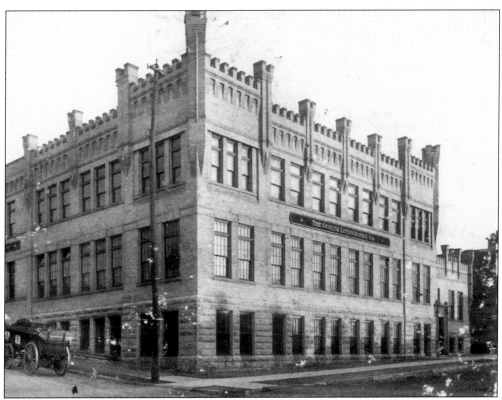

A similar design to the Pabst complex, Gugler Lithographic (above) once printed advertisements for the brewery. At a time when beer was stored in wooden barrels, German native Frederick Ketter was foreman of the Schlitz Brewery Cooper Shop. In 1890, Ketter commissioned the construction of his own cooperage shop at the foot of Schlitz Brewery near Third and Vine Streets. Its long, narrow stance with a street-facing stepped gable is likely inspired by 13th-century townhouses of medieval Northern Germany that contained the owner's residence, shop, and warehouse. When Ketter moved to North Thirtieth and Galena Streets in 1894, the building was purchased by the Geiger brothers as a warehouse for their grocery store nearby on the corner of North Third and Vine Streets. (Above, courtesy of John Steiner.)

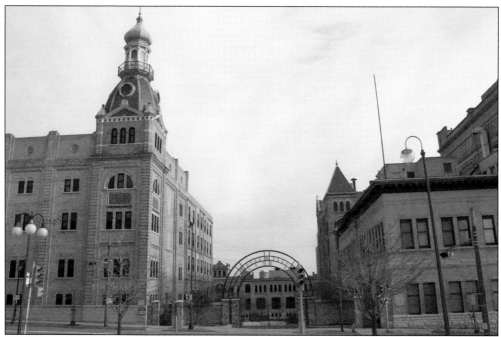

In 1856, Joseph Schlitz gained control of August Krug's brewery, for which he had been the bookkeeper. The brewery moved from its original location at North Fourth Street and Highland Avenue in 1870. Unfortunately, Joseph Schlitz was lost at sea in 1875 on a steamship voyage to Germany, at which time the brewery was inherited by the Uihlein Family. In 1895, Schlitz was the third largest brewer in the United States after St. Louis' Anheuser-Busch and Pabst Brewery. Around 1900, one of the finest German-inspired towers was constructed atop the Schlitz Brewery Stock House, echoing sentiments of 18th century German Baroque. The tiered gables on the building's west side are an elaborate interpretation of German Renaissance Revival.

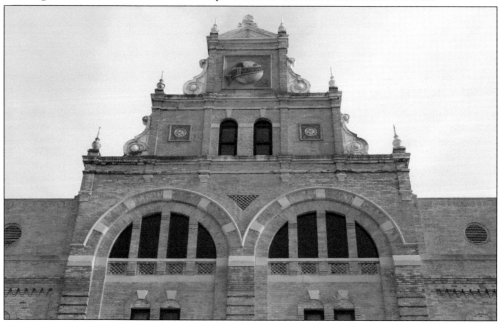

Initially a cabinetmaker and furniture retailer, German native Fred Borgwardt transitioned to undertaking in 1897. In 1902, Borgwardt constructed a new building (right) to house the funeral parlor along National Avenue in Milwaukee's south side German-American community. At the time, it was common for undertakers to operate out of storefronts instead of funeral homes, as funerals usually took place in the deceased's home. The curvilinear gable with broken pediment, intended to reflect the identity and image of the establishment's owner to passersby, exhibits the Baroque and Renaissance designs of 17th century Northern Germany. Anton Singer replaced his home with this German-inspired masonry building (below) in the heyday of South Sixteenth Street's commercial development. Constructed in 1906, the building was a commercial rental property at the ground floor; Singer lived upstairs with his family.

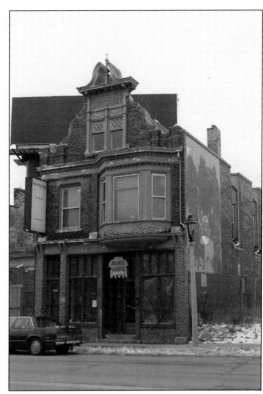

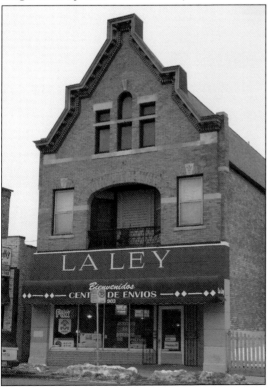

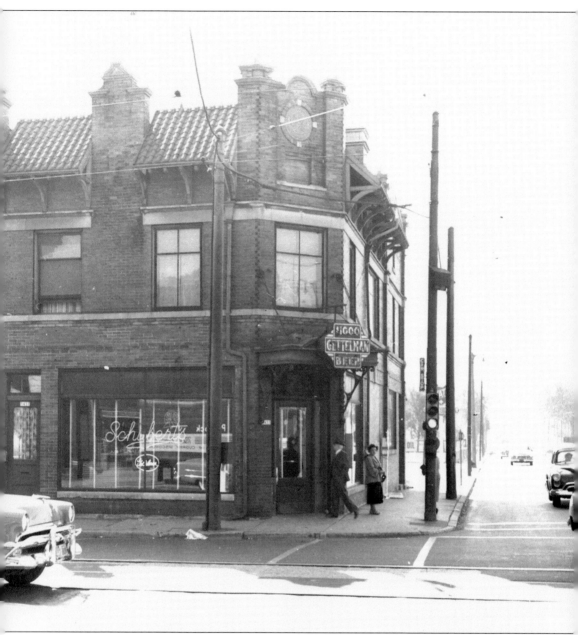

The construction of the German Renaissance Revival tavern at the corner of North Thirty-fifth and Vliet Streets, once the Milwaukee and Wauwatosa Plank Road, marked the end of the brewery-owned tavern era. Built by Pabst in 1907, the tavern was one of the last brewery-built taverns in the city with the passing of the Baker Law, which restricted the number of taverns that could be built based on Milwaukee's population. The law was likely in response to the tavern-building era, in which if there was a corner there was a tavern. Even though Pabst was the leading beer producer, Schlitz led the tavern construction with nearly 50 taverns throughout the city, most near factories and manufacturers. The Vliet tavern was a departure from the flamboyant architecture of earlier saloons. (Courtesy of Milwaukee Historic Preservation Commission.)

Eight

PERIOD REVIVALS

By the turn of the 20th century, concern peaked regarding the unhealthy living conditions of life in the center of an industrial climate. Overwhelmed by the congestion of densely populated neighborhoods and pollution produced by manufacturers, city planners began advocating for healthy and ordered development. Between 1892 and 1895, the municipal parks system developed to provide green space, fresh air, and a refuge from the congestion of the city. Following the park system, Milwaukee embarked on an ambitious boulevard system intended to create much needed space in densely built-up neighborhoods and to connect the parks throughout the city. The boulevards were set in unique, park-like neighborhoods fitted with landscaped esplanades separating the opposing lanes. They likewise encouraged better living conditions by prohibiting bothersome traffic such as vehicles carrying dirt or farm products as well as prohibiting any commercial development, thus creating exclusively residential neighborhoods. Development continued to move outward as the City annexed land at its outer edges away from the central business district. Relocation to newly platted subdivisions was further accelerated by the availability of automobiles and the extension of the electric railway. Many of these new subdivisions maintained a uniform appearance, developing largely within a decade or two between 1900 and 1930. Moreover, these subdivisions were often subject to deed restrictions intending to create neighborhoods with a certain appeal as well as the establishment of Milwaukee's first zoning code in 1920. Architecturally, this period hosted a vast array of period revivals attempting to replicate historic styles with more exactness rather than using elements of various styles to create a new one, such as Italianate or Second Empire. Moreover, for the first time, revivals drew upon an American form of architecture as Colonial Revivals replicated the Federal style. In the early 1900s, period revivals were accompanied by Arts and Crafts–inspired homes, those taking pride in craftsmanship, industrial consumerism, and well-crafted homes for the emerging middle class in the last era of architecture based in historic precedence.

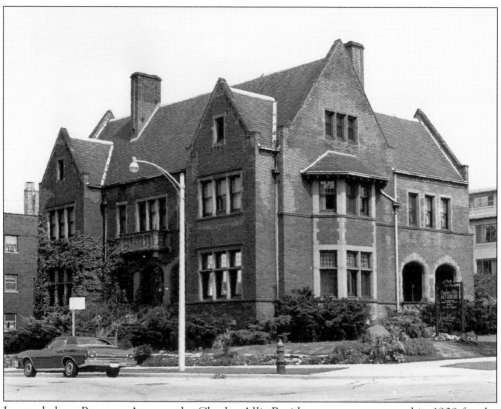

Located along Prospect Avenue, the Charles Allis Residence was constructed in 1909 for the son of Edward P. Allis. The home was designed by Alexander C. Eschweiler with Jacobean-Elizabeth and Tudor influences. President of the Allis-Chalmers Company, the first president of the Milwaukee Art Society, and a trustee of the Layton Gallery, Allis bequeathed his home as an art library and museum to the City of Milwaukee in his will. (Courtesy of Milwaukee Historic Preservation Commission.)

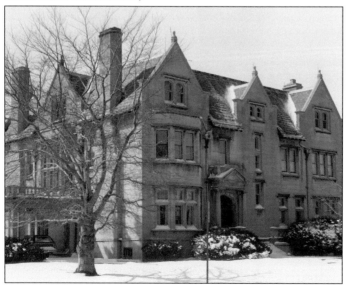

Emil Ott constructed a similar residence at the edge of the North Point Neighborhood on Lafayette Place in 1907. Designed by Ferry and Clas, the residence was constructed several years after Ott inherited Steinmeyer Grocery from his father-in-law. The Jacobean-Elizabeth Revival residence once stood among several residences along the bluff that were later razed. (Courtesy of Milwaukee Historic Preservation Commission.)

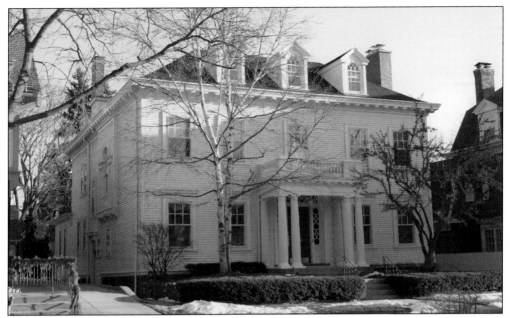

The North Point neighborhood sits on a bluff overlooking Lake Michigan, divided into North and South neighborhoods by the North Point Water Tower. The southern portion of the neighborhood came to fruition between 1895 and 1915 as prestigious residential development spread north along the bluffs on Prospect Avenue's east side to Lafayette Drive and Terrace Avenue for many of the city's long-standing wealthy families such as Brumder, Pabst, Blatz, Cudahy, Vogel, and Gallun.

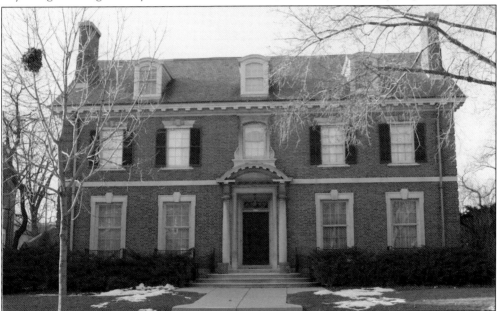

North Point's south neighborhood is predominantly English-styled and Colonial Revival or Georgian Revival residences. One such residence was constructed for tanning heir August Hugo Vogel in 1911. The Lake Drive residence is a fine example of Georgian Revival. While the exterior decoration is rich, the overall character of the buildings is restrained and dignified and reminiscent of the Georgian style found early in the East Coast's development.

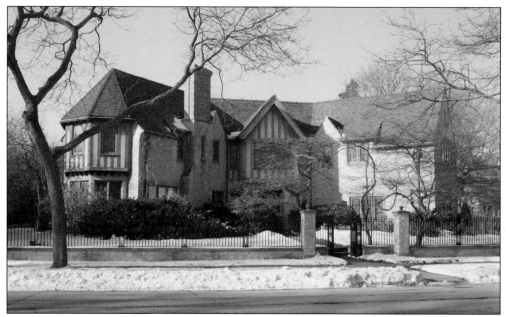

The streets in the North Point district were laid before the grid platting extended that far north and thus follow the topography in directions platted parallel to the Lake Michigan shoreline. The northern portion of the North Point neighborhood peaked in development between 1900 and 1930 and contains a high concentration of English Tudor and English-styled homes, such as the finely crafted manor of straw hat manufacturer Alfred Lester Slocum.

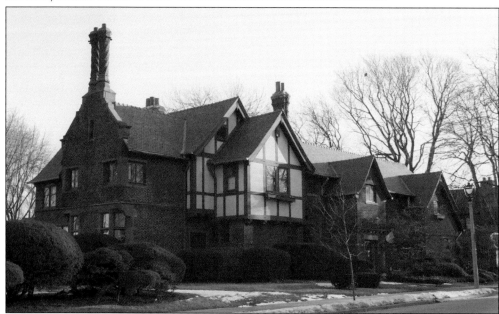

In 1915, rising Milwaukee architect Alexander Eschweiler designed the rambling Victor Brown House at the confluence of North Lake Drive and Wahl Avenue as a splendid English Tudor manor with twisting chimneys, stacks, and a series of projecting gables. As a whole, the North Point neighborhood and adjacent East Side streets maintain an impeccable collection of Colonial Revival, English Tudor, and Arts and Crafts homes.

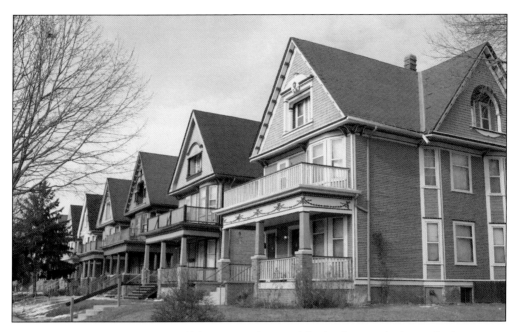

Milwaukee has maintained a well known tradition of duplex living. At large, duplexes were constructed throughout the city between the 1880s and 1920s. Duplex construction peaked between 1904 and 1916 in all wards of the city except for downtown and the Menomonee valley. The northwest side is almost exclusively duplexes. Previously referred to as two-family flats, the stylistic influences of duplexes vary between Queen Anne, bungalow, English Tudor, Arts and Crafts, and Colonial Revival. As with most of Milwaukee's residential architecture, the gable ends are set parallel to the street in response to the narrow city lots. Moreover, the gables are often the most pronounced feature of the home, carrying the majority of decorative embellishments.

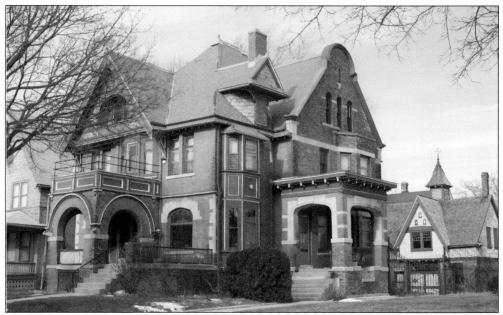

Cold Spring Park was originally one of the largest private parks on Milwaukee's west side, covering about 16 blocks between North Twenty-seventh and North Thirty-fifth Streets and West Juneau Avenue and Vliet Street until it was subdivided into residential lots in 1891. The boulevard plan was an outcome of the municipal park system begun between 1892 and 1895. Highland Boulevard between North Twenty-seventh and Thirty-fifth Streets was the first platted in 1896, followed by McKinley in 1906, which was platted through the center of the Cold Spring Park subdivision in 1906. Between 1901 and 1910, Cold Spring Park was nearly built to capacity, resulting in its architectural cohesion. Most of the residences are of the Colonial Revival, prairie, or Arts and Crafts styles but carry a heavy Teutonic sentiment in their timbered and shaped gables and heavy massing.

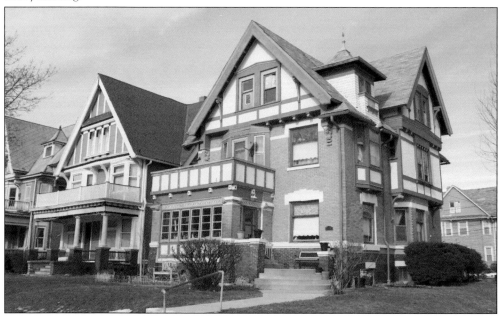

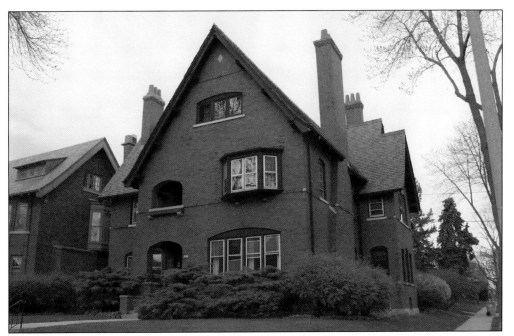

Originating in 19th century England, Arts and Crafts developed in the United States at the close of the Victorian era in the early 1900s. Unlike the English Arts and Crafts movement, the American Arts and Crafts celebrated the use of modern building materials, embracing the modern age of industrial consumerism.

The movement was likewise concerned with enriching the homes of the growing American middle class, influencing bungalow architecture that was popularized between 1915 and 1930. Usually constructed with simple exterior surfaces, Arts and Crafts homes often implemented both stucco and brick as well as adorned but prominent chimney stacks.

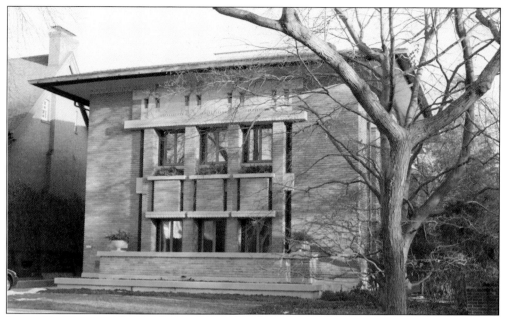

Inspired by Wisconsin's rolling, horizontal landscape, Frank Lloyd Wright's prairie-style architecture makes a clean break from European influences and is often credited with being the first true American-style architecture. The Frederick Bogk House was designed by Wisconsin native Frank Lloyd Wright in 1917 and exhibits a slightly compressed urban take on prairie style.

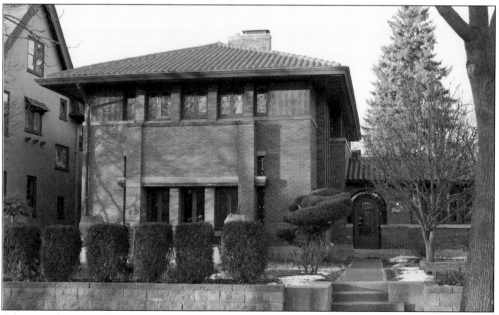

After Newberry Boulevard was established in 1906, residential development spread west from the North Point neighborhood. The boulevard is predominantly lined with Colonial Revival residences as well as prairie-style homes designed by Milwaukee architects such as Russel Bar Williamson, who developed his own interpretation of prairie-style residential design referred to as Williamsonian, seen in this 1922 residence.

The rise of the middle class spurred the development of a new housing style, the Milwaukee Bungalow, a testament to the ideology of home ownership for all. Designed with efficient floor plans, bungalows ranged from simple to elaborate in a variety of aesthetic motifs complete with attics convertible into an additional living space. The bungalows were adaptable, affordable, and could be easily detailed as each resident saw fit, making home ownership possible and attractive for the emerging middle class. Most often, bungalows were one-and-a-half-story homes—a more horizontal, landscape-oriented aesthetic than traditional two-story homes—characterized by informal, asymmetrical facades with porches tucked under projecting rooflines and exposed rafters. The efficient homes were constructed with mass-produced materials but quality workmanship, modest yet detailed and well constructed. Bungalows permeated most neighborhoods in the city but were concentrated on east, west, and northwest sides. (Both, courtesy of Milwaukee Historic Preservation Commission.)

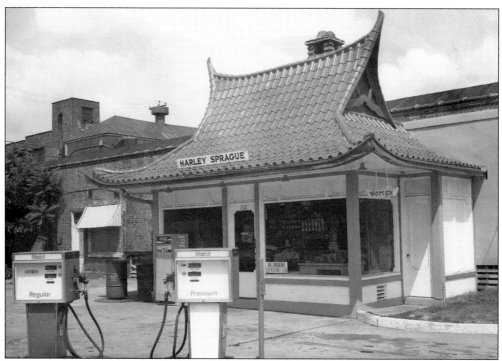

As suburban life was made possible by expanded public and the automobile, filling stations were among the first structural responses to the introduction of the automobile. In the early 20th century, oil companies began to establish full service filling stations, and by 1915 oil companies were designing eye-catching stations with exotic themes to identify their product. The stations were intended to be inexpensive and recognizable. Wahdam's Oil hired architect Alexander Eschweiler to design a prototype for their filling stations, and between 1917 and 1930 his pagoda design was used as a template for Wahdam's filling stations around Milwaukee and neighboring cities, the first station being constructed at North Fifth Street and West Wisconsin Avenue. At one time, the city boasted as many as 40 pagoda stations, but they began to disappear after 1930 when Wadham Oil merged with another company. (Above, courtesy of Milwaukee Historic Preservation Commission; below, courtesy of Historic Photo Collection/Milwaukee Public Library.)

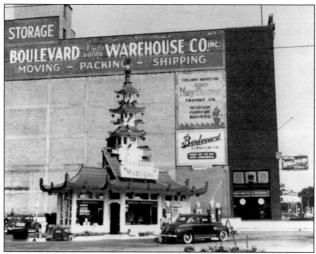

Nine

ECLECTIC REVIVAL,
ART MODERNE,
AND ART DECO

In regard to a city so heavily influenced by the presence of German residents, their traditions, and the production of beer, the period between the First World War and the Great Depression changed Milwaukee. Following the onset of World War I and peaking in 1917 when the United States joined the war, a destructive anti-German sentiment stripped Milwaukee of its ethnic heritage, with residents changing their names, buildings being razed, and German traditions being suppressed. In 1920, Prohibition put a stop to one of the city's claims to fame when breweries were forced to stop beer production, sell their saloons, and produce various other products to weather the movement. It was also during this period that immigration trickled to a halt, which up until that point had aided in Milwaukee's unique culture. With the introduction of mass production, the automobile, and the efficient conveyance of national trends through mass publications, Milwaukee began to assimilate into its next cultural phase. The introduction of the automobile created the need for auto-oriented commercial districts, in contrast to the early retail and commercial districts that relied on the streetcar lines and main thoroughfares. Large national department stores ushered out the era of local shopping districts and personally owned "mom and pop shops." Milwaukee's residents grew tired of older establishments of the past and began to yearn for new and untainted. Architecture followed, as it moved away from historicism and looked to new forms related to the industrial and automobile. A later version of period revivals was popularized in the 1920s, this one taking design cues from exotic themes such as Egyptian, Byzantine, Moorish, and neo-Gothic. A so-called fantasy architecture evolved, drawing influences from Eastern architecture as well as the development of movie palaces during the rise of motion pictures. By the mid-1920s, architecture was looking forward, making a break from the past and embracing the modern age in the form of America's first modernistic styles: art deco and art moderne.

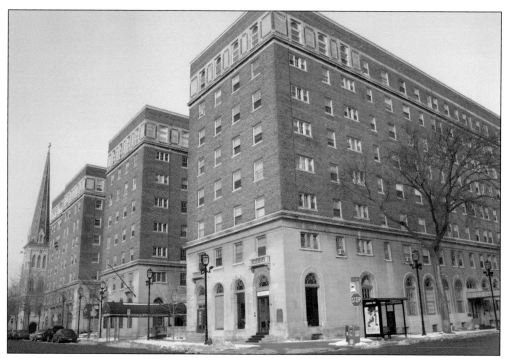

An interesting characteristic of 19th-century Milwaukee was the ability of all classes to acquire home ownership, making the presence of apartment buildings relatively uncommon until the 20th century, at which time a shift in living conditions and population density changed housing types from multiroom private houses to multiunit apartment buildings. Between 1900 and 1935, an abundance of masonry apartment buildings were constructed in Yankee Hill, along Prospect Avenue, and on the west side. Initiated by the Buena Vista Apartments discussed previously, the finest were constructed along Prospect Avenue and the Yankee Hill neighborhood, peaking during the 1920s with apartment-hotels such as The Astor (above). Similarly along Wisconsin Avenue, the grandiose mansions for which the street had previously been named gave way to apartment complexes and apartment-hotels such as the Sovereign Apartments (left).

Centered along Wisconsin Avenue's 20th century shopping district, the Plankinton Arcade mimicked European sunlit shopping arcades with a sky-lit central rotunda and staircases surrounding the statue of John Plankinton. Designed by Chicago architects Holabird and Roche in 1916, five office levels were added to the two-story neo-Gothic Revival retail arcade in 1924 and 1925.The basement previously housed bowling lanes, pool tables, a Turkish bath, and large restaurant and bar. (Courtesy of Milwaukee Historic Preservation Commission.)

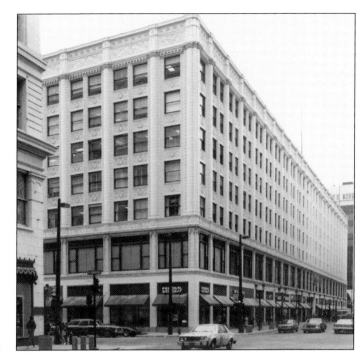

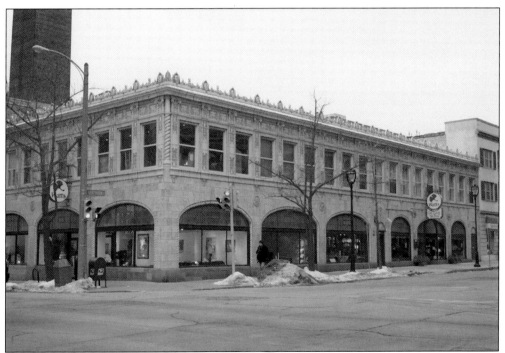

Since 1869, George Watts and Sons have been selling fine china. In 1925, the company erected a new building at the northwest corner of Jefferson and Mason Streets clad entirely with glazed terra-cotta detailed with Mediterranean motifs. In this period, terra-cotta grew in popularity and replaced hand carved stone as a facade material. Light colored terra-cotta was usually detailed with Spanish, Mediterranean, or Middle Eastern motifs.

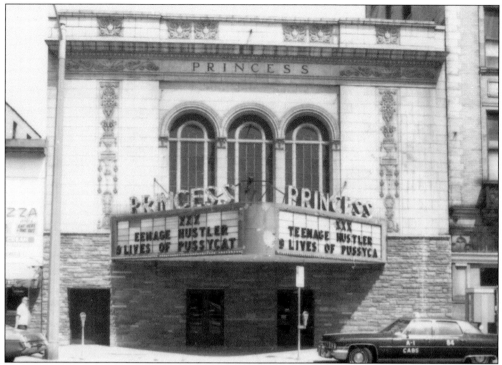

Constructed in 1909 by movie palace magnate Thomas Saxe, the Princess was the cream of the crop at the time with cork-covered floors to prevent reverberation, a five-piece orchestra pit, and a pipe organ with 27 stops, reportedly the first of its kind in a Milwaukee theater. After showing family-oriented Western genre films for generations, the Princess Theater became an adult film house in the 1950s until its demise in the 1980s. (Courtesy of Milwaukee Historic Preservation Commission.)

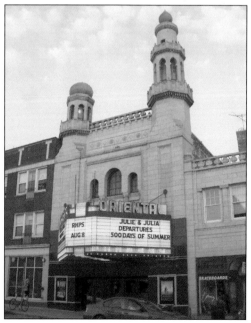

During the 1920s, America saw the rise of "movie palaces" as an original form of architecture intended to create an escape from everyday life into a land of mystery, romance, and the exotic. The Oriental Theater, the last operating movie palace in Milwaukee, was built in 1927 in an East Indian motif, originally with only one screen but now contains two smaller adjacent theaters.

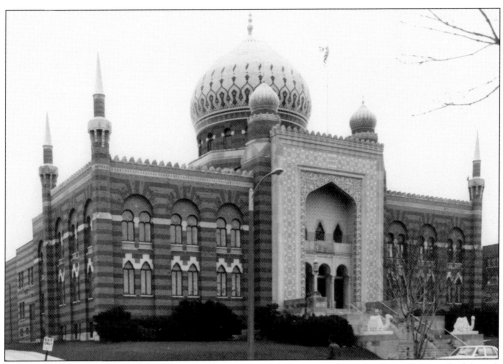

At this time, Masonic and fraternal halls grew in popularity such as the Tripoli Temple (above) on West Wisconsin Avenue constructed in 1928. Alfred Clas designed the hall as a fine example of 1920s fantasy architecture. The mosque-inspired building takes influences from Moslem architecture of Persia and North Africa seen in the mosaic tiles on the dome, reminiscent of 16th century Persia. Originally built in 1925 with Spanish Colonial and Mediterranean Revival motifs, the Eagles Club (below) served as a lodge for the second largest Fraternal Order of Eagles in the United States. The Eagles Club included a bowling alley, swimming pool, and Devine's Million Dollar Ballroom that booked the nation's top big bands from the 1930s up to 1968. (Both, courtesy of Milwaukee Historic Preservation Commission.)

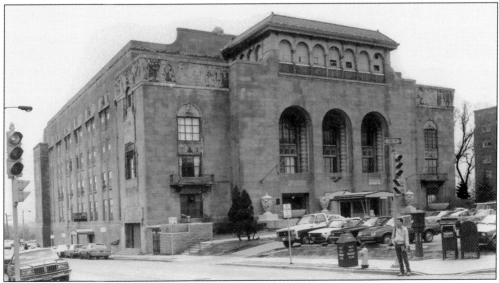

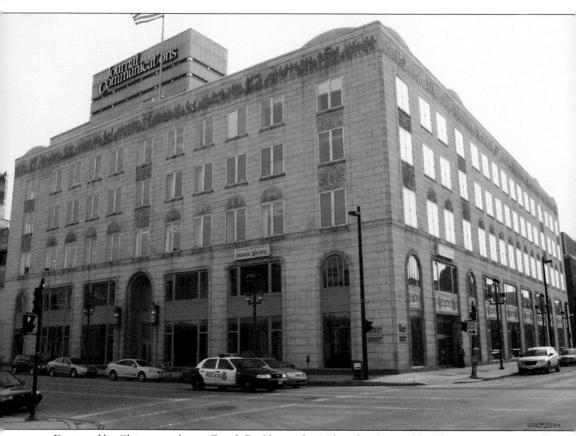

Designed by Chicago architect Frank D. Chase, the Milwaukee Journal building was constructed in 1924 at the southeast corner of West State and North Fourth Streets. The art moderne building exhibits smooth wall surfaces, a flat roof, and horizontal incising along wall surfaces to emphasize horizontality. As was common with art moderne, the building contains a low relief frieze depicting the history of communication.

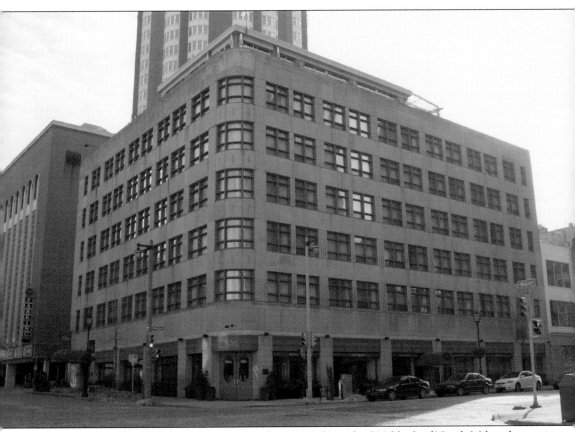

The Metro Hotel ends the time capsule of architecture along the 700 block of North Milwaukee Street. Constructed in 1937, the art moderne hotel exudes industrial and machine-like sentiments with its metal-clad exterior. In addition, the corner is curved, reportedly inspired by the way an automobile zooms around corners.

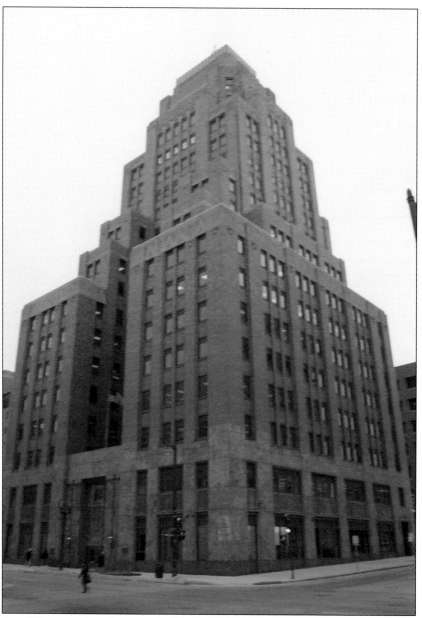

The art deco Wisconsin Gas Company building was designed by Eschweiler and Eschweiler in 1930 featuring a gradation of dark granite and red, pink and cream brick to emphasize the verticality of its cubic setbacks as well as low relief Aztec motifs adorning its surfaces, all characteristic of art deco architecture. The building's smooth wall surfaces and polychromatic detail are indicative of both art deco and art moderne; however, the Wisconsin Gas Company building includes towering setbacks and vertical projections emphasizing verticality, unlike the horizontal treatment of the preceding art moderne buildings. Both styles developed out of the Exposition Internationale des Arts Decoratifs and Industriels Modernes in Paris in 1925, striving to express modern architecture for the machine age without historical precedence, focusing on the future rather than the past. Neither style was popular amongst residential architecture, but both were personified in newer building types like skyscrapers, tall apartment buildings, and other commercial buildings.

BIBLIOGRAPHY

Garber, Randy, ed. *Built in Milwaukee: An Architectural View of the City: Prepared for the City of Milwaukee, Wisconsin, by Landscape Research.* Madison, WI: Department of City Development, 1981.

Gurda, John. *The Making of Milwaukee.* Milwaukee, WI: Milwaukee County Historical Society, 1999.

Handlin, David P. *American Architecture.* 2d ed. New York: Thames and Hudson World Art, 2004.

Mass, John. *The Gingerbread Era: A View of Victorian America.* New York: Greenwich House, 1983.

Perrin, Richard W. E. *Milwaukee Landmarks.* Milwaukee, WI: Milwaukee Public Museum, 1979.

Discover Thousands of Local History Books Featuring Millions of Vintage Images

Arcadia Publishing, the leading local history publisher in the United States, is committed to making history accessible and meaningful through publishing books that celebrate and preserve the heritage of America's people and places.

Find more books like this at
www.arcadiapublishing.com

Search for your hometown history, your old stomping grounds, and even your favorite sports team.